WITHDRAWN

Delacroix
The Great Draughtsmen

Delacroix

Claude Roger-Marx
Sabine Cotté

Pall Mall Press London

Delacroix
Translated by Lynn Michelman

General Editor
Henri Scrépel

Originally published in French under the title
l'Univers de Delacroix, *in the series* Les Carnets de Dessins.

Copyright © *1970 by Henri Scrépel, Paris.*

Pall Mall Press Ltd.,
5 Cromwell Place, London SW7

First published in Great Britain in 1970.
ISBN 0 269 02727 0
Printed in France.

Delacroix
The Great Draughtsmen

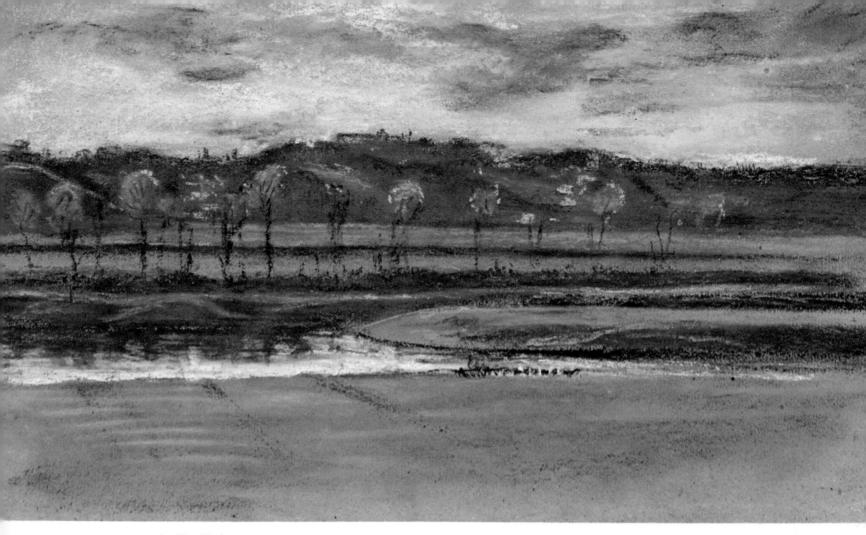

1. The Night
Pastel

Louvre, Paris

Contents

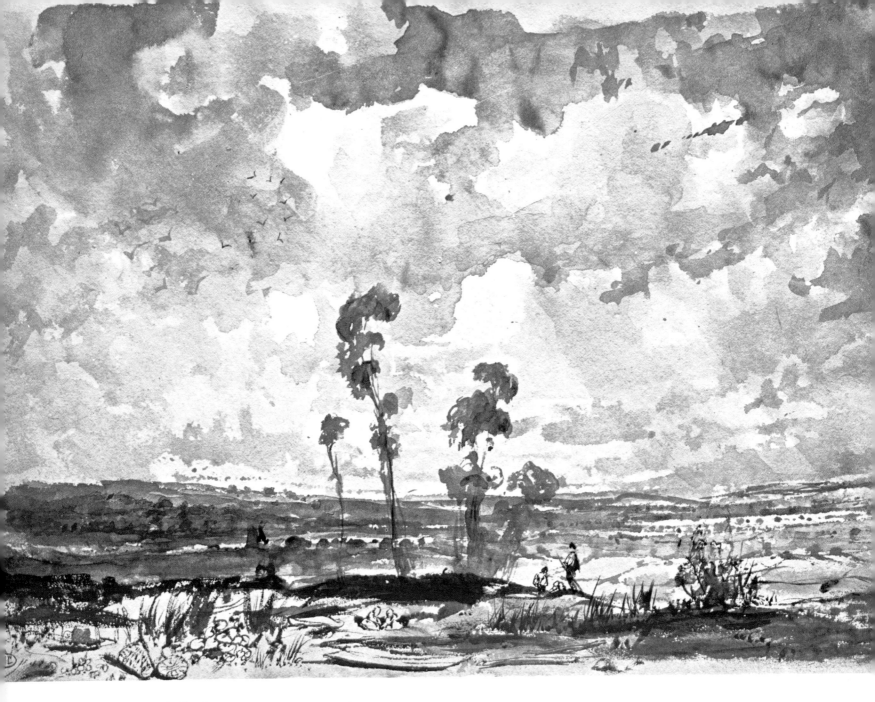

2. Landscape
Wash, page from a sketchbook

Louvre, Paris

10

I

"Neglect Nothing That Can Make You Great"

Delacroix was never to forget this advice, given to him by Stendhal. But how could he do other than follow it, for it only encouraged the natural bent of an inspired young man who, from his earliest days, felt that he had wings or, rather, that he was made to soar above reality.

Imagination, which Baudelaire was to christen the "queen of the faculties," was so intense in him that, as a youth enamored of poetry, he considered himself a poet and wrote tragedies. If he opted for painting, it was because this seemed to him the best means of unifying the exterior world with all that incessantly fermented within him, of giving substance to his dreams. At twenty years of age he did not undertake the great themes as the kind of history painter then fashionable, but rather because he felt constrained in limiting himself to the portrait, the nude, or the landscape. For him the sublime was far from being a pose or the artificial product of his will—as it was for David and Ingres—but was instead his natural element. More accurately, he discovered it everywhere in nature. The great genres permitted him to externalize the fire that burned within,

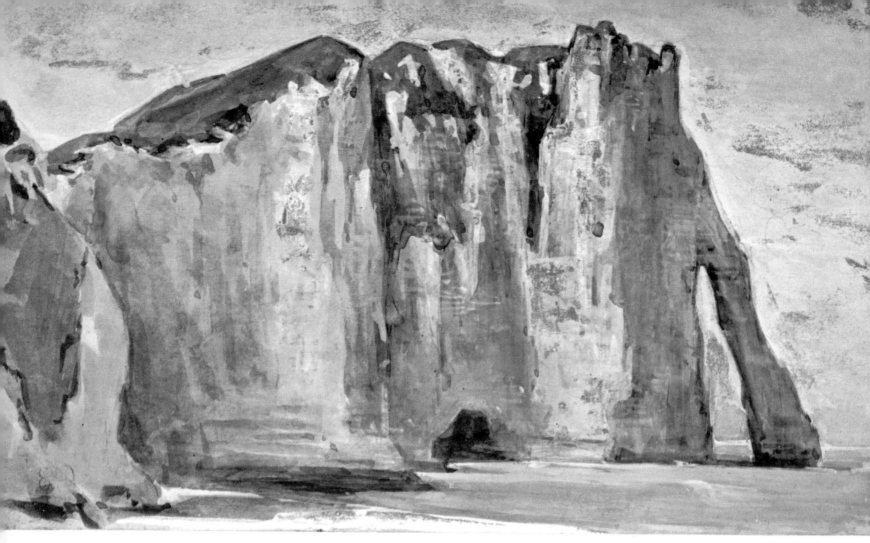

3. Cliffs at Etretat
 Watercolor

Boymans Museum, Rotterdam

to express through the voices of his heroes what he felt to be heroic in himself, to adventure, though knowing all the dangers that he risked, into unexplored domains: in short, to prove himself unfettered by the tangible, the observed, the certain, while tempted by all hypotheses and all possibilities—to be, in a word, *universal*.

To begin this study on the note of Delacroix's themes might seem anachronistic to some, for we live in a time that has seen fit to peremptorily banish subject matter.

When Baudelaire said to Manet that he was "the first in the decay of his art," he foresaw one hundred years in advance the curses that were to haunt the art of painting with increasingly sad consequences.

Despite the existence of admirable painters who continue to breathe new life into landscape, the nude, interiors, and still lifes, there are few nineteenth- and twentieth-century artists whose compositions constitute, by virtue of the richness and multiplicity of their elements, summations of human and pictorial experience. The exercise of memory and imagination atrophies from day to day. Even artists like Degas did not fulfill their initial promise. The excesses of the critical spirit and a profusion of theories have become elements of inhibition. Today art has been replaced by technique. One day soon, proofs and experiments will predominate. The painter will tend to be merely a cultivated craftsman in revolt against culture, a craftsman of great taste but one who reasons endlessly or contents himself with cautiously repeating the same tricks.

The French school's greatness and weakness lies in its inclination to prudence and economy. It has always been frightened by lyricism and abundance. Wanting too much to prove that they are their own masters, contemporary painters have seen their field of action reduced to almost nothing. Wary of confused genres and the misunderstood issue of the relationship between literature and art, they conceive only of an abstract world detached from ours. They have burned their bridges behind them and with these, the earth, the sky, the human face, and, what is far more serious, the richness of the inner world.

If contemporary art is so meager, despite its proliferation, it is because most artists, though they use their eyes, are no longer seers. All the great artists of earlier times, while relying upon the known, evoked at the same time a complementary unknown. They did not have to be pious to marvel at a starry night,

4. Landscape
Wash, from a page of studies

Louvre, Paris

at the beating of their hearts, their sleep, or their awakening. It is sad to admit that those dedicated to the representation of the perceptible world today find it perfectly natural to cleverly exploit an increasingly minimized domain like other specialists. Has the world reached the age of senility as Baudelaire feared so that, detached from the heights, it aspires to no more than descent? Not only have God and the gods disappeared from the world, but so too has that god that all men once were in their own eyes. Almost all our young people believe that the world has exhausted itself and a horror of living has replaced the song of gratitude that, for centuries and centuries, has been the act of painting.

14

Throughout his life, Delacroix never ceased to converse with the gods—or with God—and, sober as he was by temperament, he preserved his sense of wonder at all that he saw and exalted the enigmas that all things revealed to him.

I know very well that even today, for various reasons, opinion about him is still far from unanimous. His tempestuous genius defies all definitions. How could his art, made of contrasts as it is, not lend itself to misunderstandings? He charms, but sometimes he irritates. To this day he is difficult to come to terms with, and if at times he discourages the friendship of the eyes it is because color, his great means of communication, has betrayed him. How many flowers have lost their freshness and their brilliance! Fashions too have changed; many gestures that were once meaningful now seem to be poses and many of the tales recounted in his works have slipped into obscurity. But how trivial this aging is compared to the agitation, the enchantment, the tonic exaltation that flows from his hand. These works of rich and prodigious diversity, while stimulating all our faculties, seem through their inexhaustible radiance to belong less to the past than to the present and the future.

5. Landscape
Wash, from a page of studies

Louvre, Paris

A Futile Quarrel

There are far fewer men who "see" than one would think. Most men use their eyes for utilitarian purposes. One would readily admit that before a landscape, a farmer thinks of the earth that he has to fertilize or sow, a surveyor of its dimensions, a land agent of its sale price. But very often even those whose mission it is to evoke the visible world with their brushes, as well as the critics called upon to judge them, look at nature or judge the products of art through conventions, theories, and habits, rather than their eyes.

During almost all ages, especially our own, all kinds of puerile conflicts have pitted doctrinaires against each other: for the latter painting and sculpture are hardly more than pretexts for literary jousts, treatises, and vague philosophizing. According to the fashion of the moment, they defend or oppose one or another point of view when, in fact, "view" counts for very little. These interminable and obscure debates drag on and are legislated among blind men, recalling those of Bruegel the Elder. Unfortunately, many painters and sculptors are influenced by these debates between historians and critics and submit to the dominant aesthetic of the day, not yet being sufficiently confident of themselves to listen to their own truth alone.

At the beginning of this essay on Delacroix and his drawings, it would be fitting to consider one of the great quarrels that divided opinion for several centuries and which, throughout his life, victimized the painter of *The Massacres at Chios* (1824, The Louvre, Paris). Accused of not knowing how to draw or of painting with a "drunken broom," he responded unremittingly to these charges through his writings. He went so far as to entrust Piron, the executor of his will, with the task of dispersing by public sale at his death not

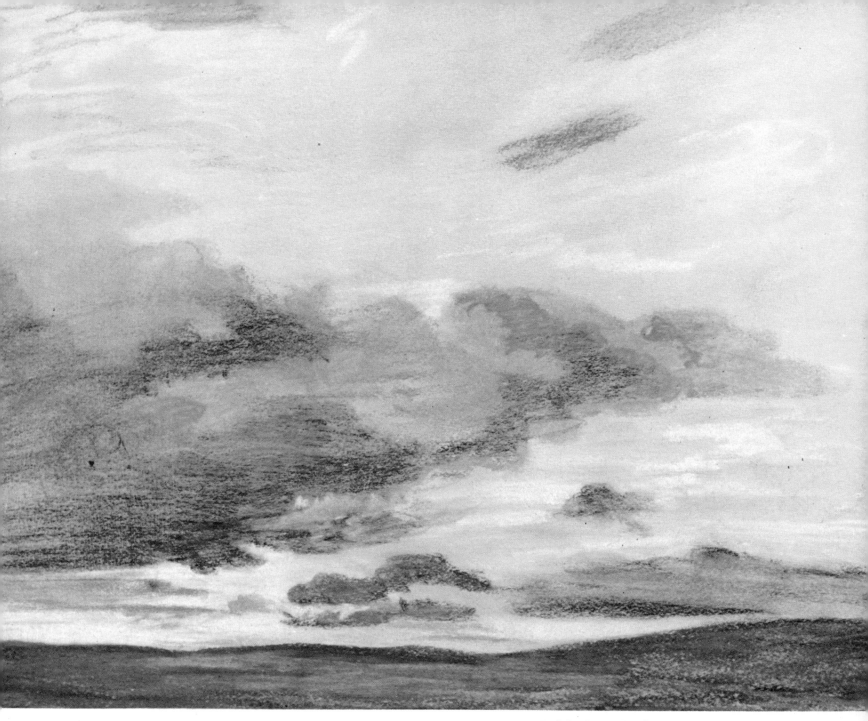

6. Lake Beneath a Stormy Sky
Pastel

Louvre, Paris

only his paintings but the innumerable drawings, watercolors, and pastels that he had jealously preserved in his portfolios in order to protest, according to Burty, who classified them, against the reproach of facility that had followed him all his life.

The quarrel in question is the one between "colorists" and "draughtsmen." Even under the *ancien regime*, versifiers, philosophers, pamphleteers, and dramatic writers joined in the debate aroused by painting. Molière, for example, despite his horror of all forms of humbug, defended Mignard against Le Brun in a poem dedicated to the glory of the Val-de-Grâce ceiling: using terms borrowed from Dufrenoy, he praised this decoration for

> The union, the harmonies and the warmth of the colors
> Contrasts, affinities, diversities of hue
> The distribution of light and shade.

From the middle of the sixteenth century on, the Italians were already indulging in all sorts of controversies. The famous program prescribed by the Carracci to unite Titian's color with Michelangelo's drawing became the occasion for a variety of commentaries and conflicts. Whereas Vasari saw the ultimate achievement of all art in the Sistine frescoes, Ludovico Dolce exalted the charms of Titian's color. Beginning in 1667, the Royal Academy of Painting and Sculpture instituted a series of "lectures" by Le Brun, Philippe de Champaigne, Noiret, and Roger de Piles, whose commentaries on the masterpieces of Raphael, Titian, Veronese, and Poussin, represent the first skirmishes of a battle that was to be constantly reignited in France. One would have thought that the distinction between *designo* and *colore* was the only problem worth discussing among painters and connoisseurs. By the end of the seventeenth century the colorists had won an ephemeral victory. However, throughout the following two centuries, the quarrel between Poussinists and Rubenists, like the argument that divided Ancients from Moderns, continued to reverberate, despite the efforts of several rare conciliators who were persuaded of the inanity of these oppositions and who recognized that one could no more separate color from drawing than the present from the past or form from content.

The great figure of Roger de Piles, engraver and brilliant patron of the arts, contrasts sharply with those dogmatists whose considerations, usually dictated by personal grudges or envy, proved only the narrowness of their mind and the limitations of their culture. In 1699 Piles dared to tell them, during the

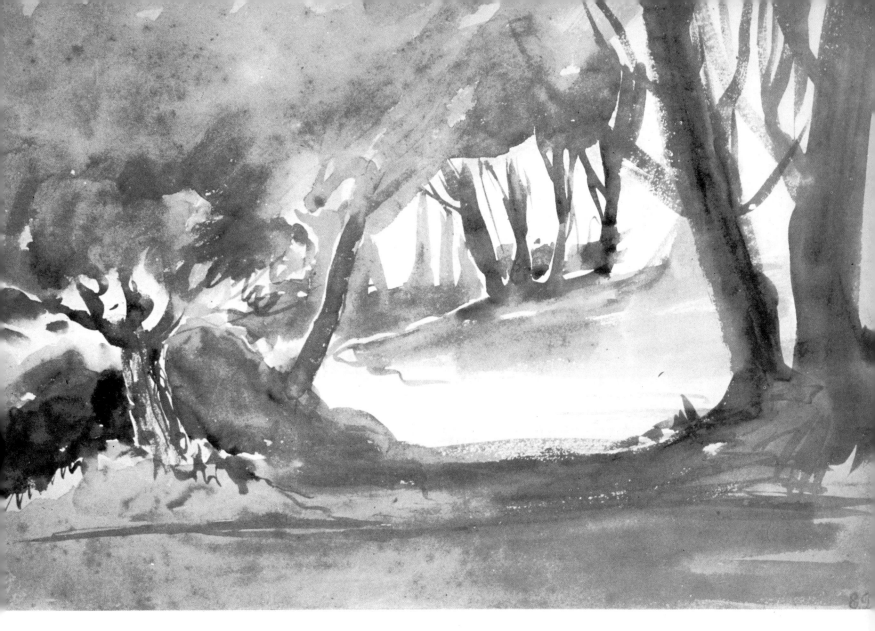

7. Interior of a Forest
Wash

Louvre, Paris

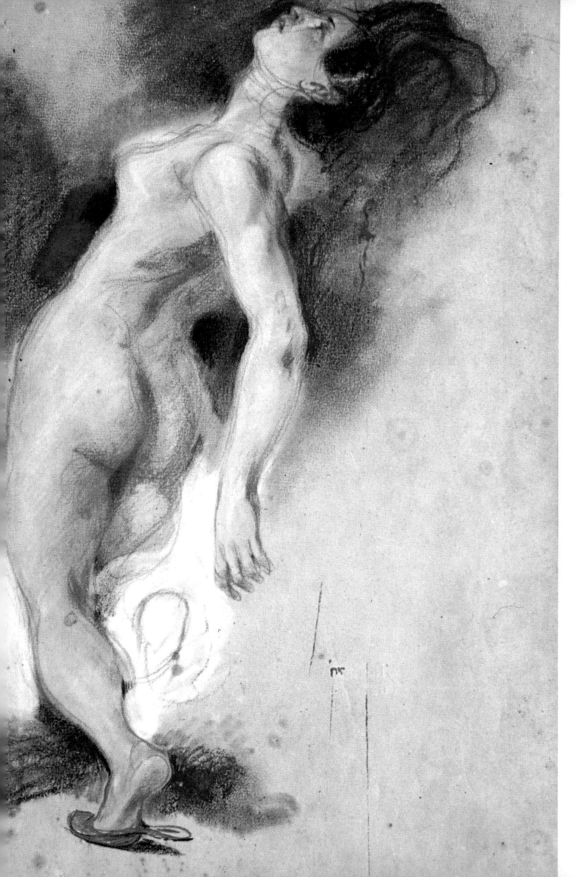

9. Study
for the "Martyrdom of Saint Stephen"

Louvre, Paris

8. Study of a Female Nude
for the "Death of Sardanapalus"
Pastel

Louvre, Paris

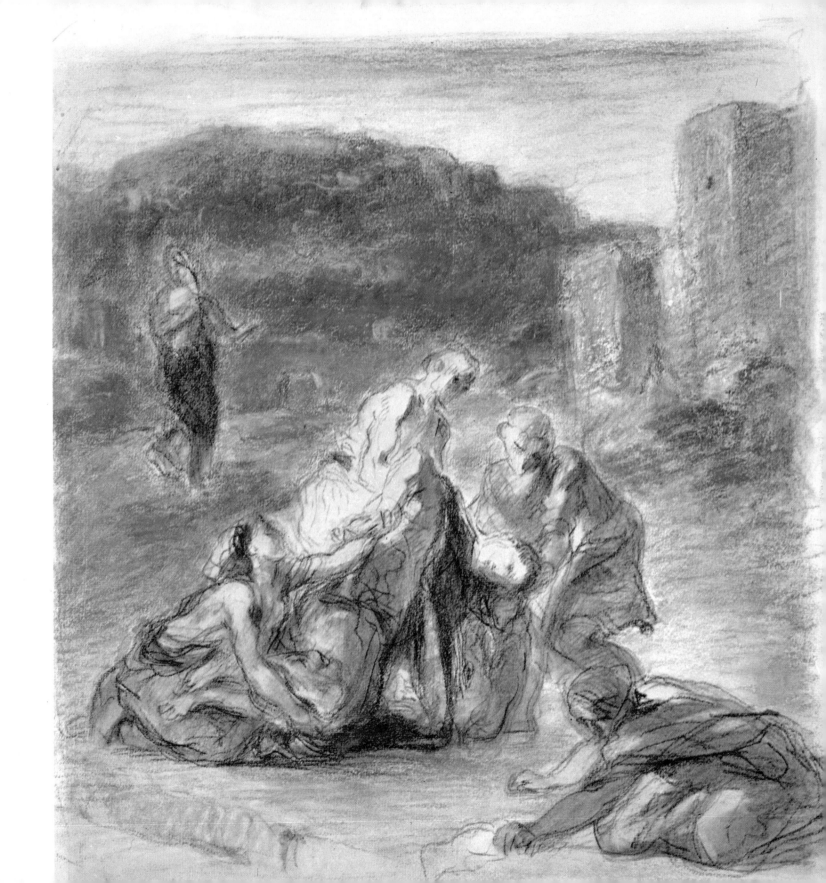

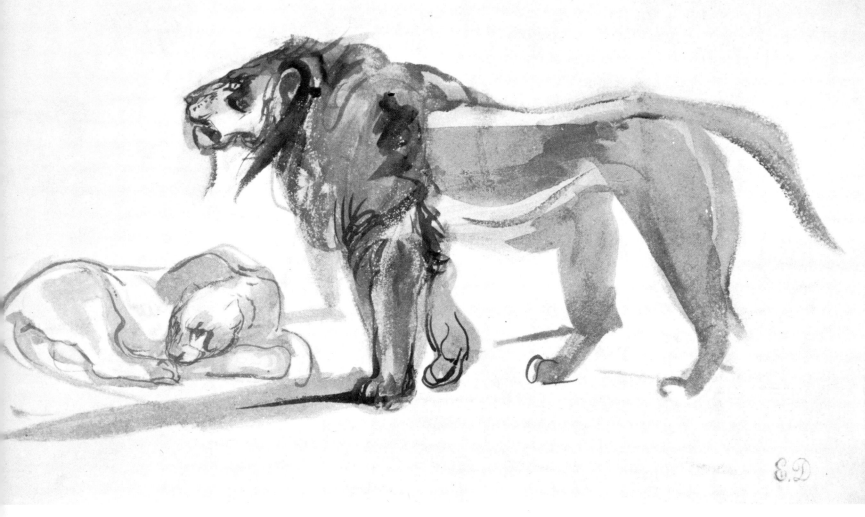

10. Study of Lions
Wash

Private collection

course of a lecture program, "Since the establishment of this Academy, we have seen that it has not only been unable to form many painters and sculptors who have surpassed the ancients, the renovators of these two arts; it has not even been able to equal them." The author of *Conversations sur la Connaissance de la Peinture, Traite du*

Peintre parfait, and *Connaissance des Dessins et de l'utilité des Estampes* is known for having, as he said himself, "disinterred Rubens," who was considered beneath mediocrity by nearly all Piles' contemporaries. Indeed, Piles was to write a life of Rubens, and went so far as to declare him superior to Titian and Raphael. Piles admired him not solely as a colorist but as a draughtsman as well. "One would hope," he wrote concerning the *Lion Hunt*, "that those who find so much fault with Rubens' drawing, had themselves the same exactness in their contours, the same resolution, and the same ring of truthfulness." This alliance between color, light, and the feeling of general harmony that is so satisfying at first glance, he very aptly called the *tout-ensemble*.

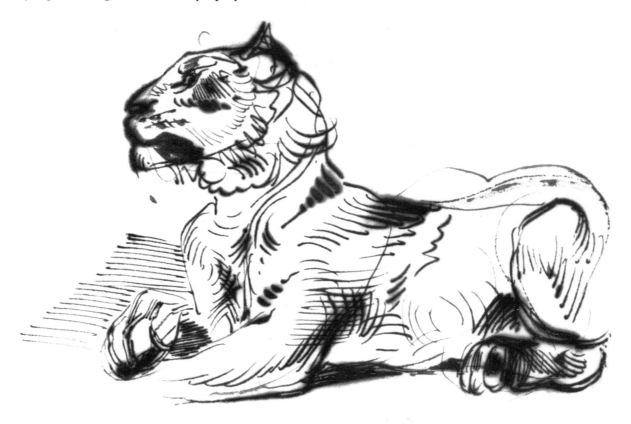

11. Study of a Tiger
 Pen

Private collection

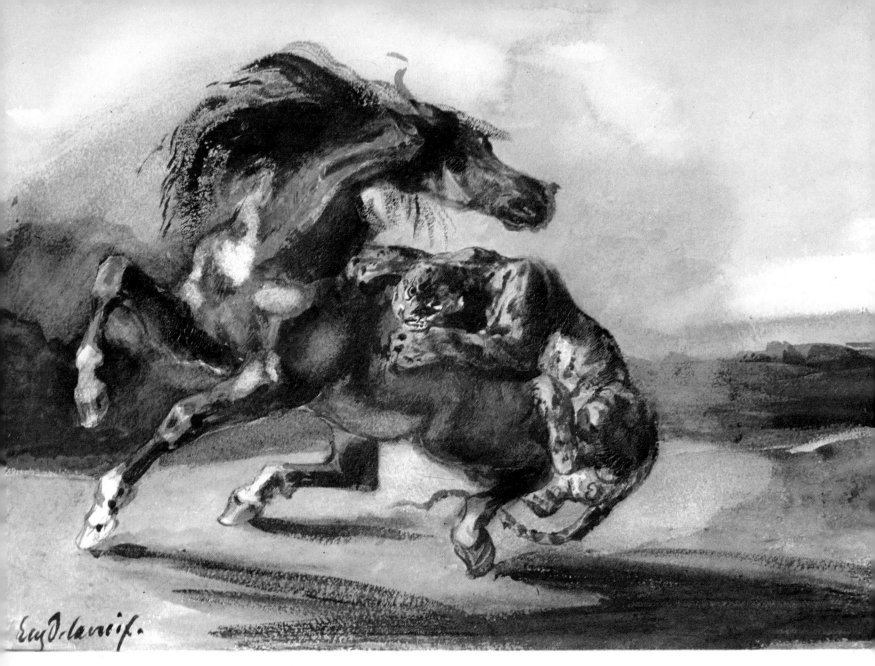

12. Tiger Attacking a Wild Horse
 Watercolor

 Louvre, Paris

13. Study for "The Massacre at Chios"
 Watercolor

 Louvre, Paris

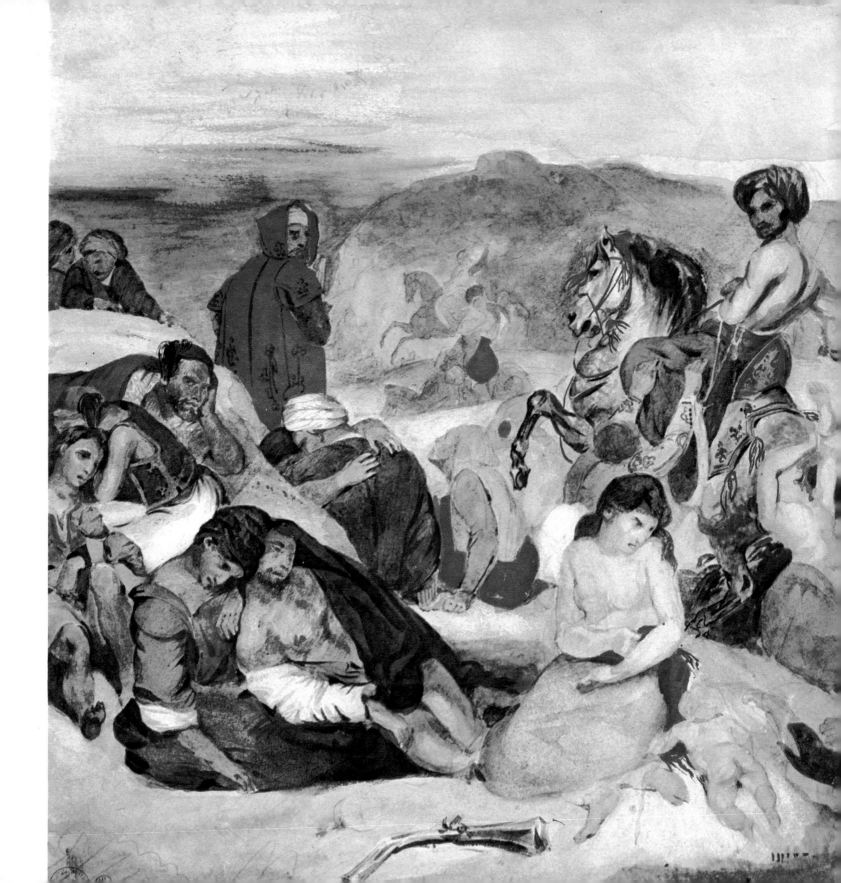

At the risk of provoking sarcasms from those critics for whom respect for fixed proportions was the unique criterion, Piles admired *The Queen of Persia at Alexander's Feet* for "its a beautiful negligence that seems to have been put there by chance." He insisted on the role of reflections in painting. There is no doubt that had he lived longer he would have defended Watteau and Fragonard and, in the next century, he would have, with Baudelaire, admired Delacroix's drawing as muchs, if not more than as those of Ingres.

Let us see now with what lucidity Delacroix, in his *Journal* and his various writings on Art, intervened, in his turn, in this interminable and futile quarrel.

"Critics do not always agree on the qualities essential to establishing perfection. Those who would be tempted today to condemn Beethoven or Michelangelo in the name of regularity and purity, would have absolved them and praised them to the skies in a time when other principles triumphed. The schools have found these principles sometimes in drawing, sometimes in color, sometimes in expression, sometimes—believe it or not—in the absence of all color and all expression. ... It is reasonable to assume that the great artists of all times certainly did not bother with all these distinctions. Color and drawing were the necessary elements that they had at their disposal, and they did not apply them in order to make one predominate over the other. It is their own inclination that leads them unconsciously to emphasize certain particular merits. Every one of the great painters has used color or drawing in a manner that accorded with his spirit and, above all, in a way that would give to his work that supreme quality that the schools do not mention and that they cannot teach : the poetry of form and color. It is on this ground that color and drawing meet, above and beyond all schools."

And to conclude: "If the great painters were to be reunited, they would recognize each other very quickly by a common sign, that is, their power to express the beautiful which each of them achieves by a different route." In an article, Des Variations du Beau, he states :

"One says of a man in order to praise him that he is unique. Can we not affirm, without paradox, that it is this singularity that enchants us in the great poet and the great painter; that this new aspect of things revealed by him astonishes us as much as it charms us, and that it produces in our souls the sensation of the beautiful, independently of other revelations of the beautiful which have become the patrimony of the spirit for all time and which are consecrated by a long admiration."

And elsewhere, he speaks of this "talisman" which each genius carries in himself.

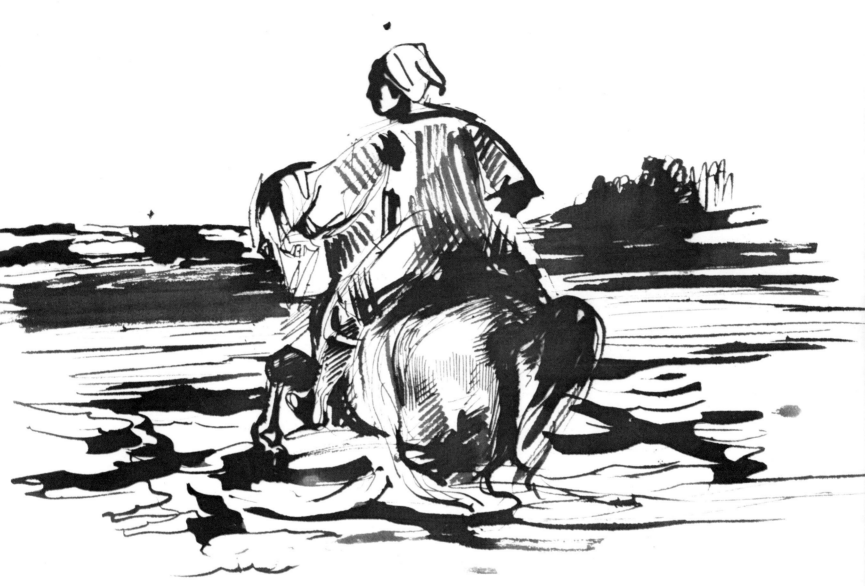

14. Moroccan Rider Fording a River
Pen and ink wash

Louvre, Paris

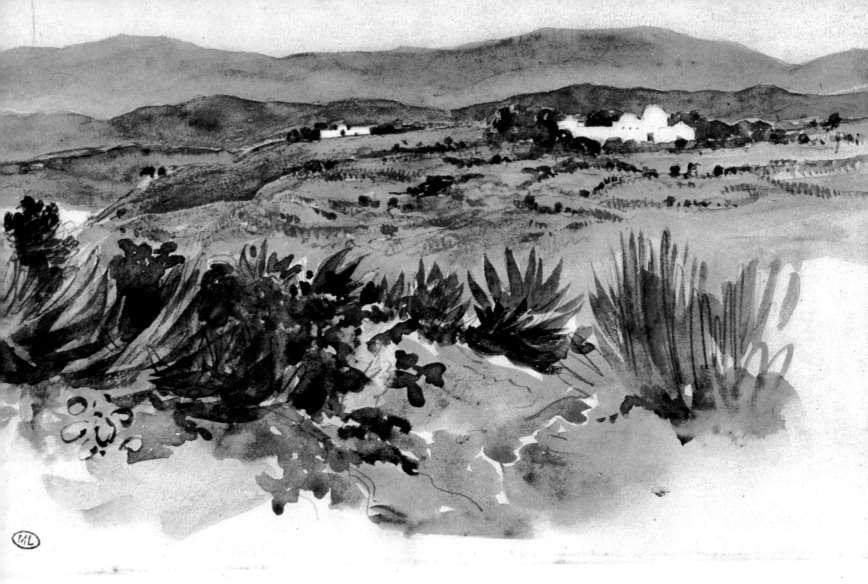

15. Outskirts of Tangiers
 Watercolor, page from a sketchbook

 Louvre, Paris

It is as true for Delacroix as for Rembrandt, Daumier, or Toulouse-Lautrec that one cannot really know the artist without turning to his preparatory work, the inspired anticipations—the drawings and watercolors. Furthermore, given the condition that time has inflicted on many paintings, we must turn to the evidence provided by their creators' first thoughts if we want to imagine their original brilliance. We can thus study the phases that an idea has passed through, the hesitations, the renouncements, the growths, the regrets, of which all great works are the ultimate outcome.

Throughout his life, as we have said, Delacroix turned his intelligence and ardor to specifying the sense of currently used words such as "sketch" or "finish." He dreamed of writing a dictionary which would precisely define those words which drift around all studios and whose original meaning has often become distorted: for example, proportions, reflection, local color, contour, foreshortening, contrasts, halftones, sketch, finish—words that summarize the history of all artistic creation. "With great artists," he wrote, "the sketch is not a dream, a vague cloud; it is something other than a coming together of barely graspable features. The great artists alone set out from a fixed point, and it is this pure expression to which it is so difficult for them to come back to during the execution of their works, be it lengthy or rapid."

This idea of the initial sketch as a complete embryo is admirably elucidated by Baudelaire, who frequently borrowed from the painter he so highly esteemed. These borrowings extend even to vocabulary, so that one might well ask who is the author of these phrases: "The whole universe is only a store-house of images and signs, to which the imagination gives a place and a relative value." Delacroix expressed himself in terms that are scarcely different: "The forms of a model, be they a tree or a man, are only a dictionary to which the artist goes in order to reinforce his fugitive impressions, or rather to find a sort of confirmation of them. Before nature itself, it is our imagination which makes the picture."

"A good painting," continues Baudelaire, "equal to the dream which gave it birth, must be produced like a world. A painting executed harmoniously consists of a series of superimposed paintings, each new layer giving the dream greater reality and making it rise one degree more toward perfection."

Not for an instant does Delacroix conceal how difficult this fidelity to the initial idea is: "It often happens that the execution itself, or completely secondary difficulties and considerations, deflect one's intention." And elsewhere: "This is the way one ought to do oil sketches, which would have the freedom

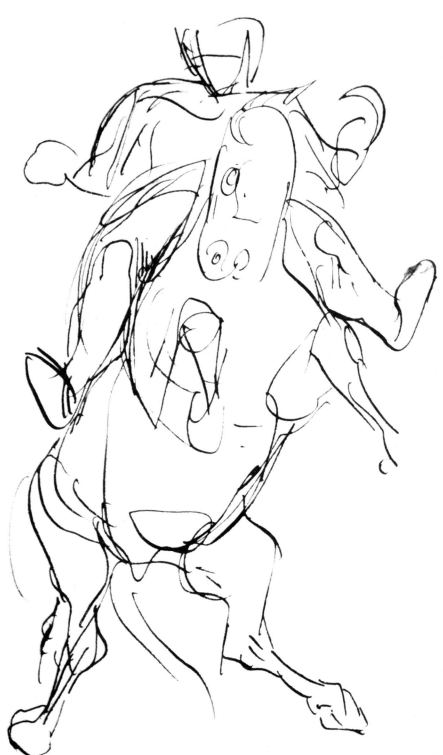

16. Sketch of a Rider
 Pen, from a page of studies

 Louvre, Paris

and freshness of rough drawings." He planned to devote a study to the difficulty of preserving the expression of the definitive sketch: "Success in the arts is not a matter of abridging, but of amplifying, and, if possible, of prolonging the sensation by all available means."

Delacroix constantly insists on the necessity of eliminating cleverness, of fleeing the infernal facility of the pen or pencil. To attain an effect by the simplest means, to preserve before nature the innocence that he admired in the primitives—that was the only cleverness Delacroix admired: "Make mistakes if necessary, but execute freely. Science is almost always fatal to the artist. Devices for facile rendering diminish the artist and tie him to mannerisms." From this follows his severity toward the Carracci: "They wanted to be scholars and seemed to be. From that point on, the academic genre was born." His opposition to so-called naturalists and realists is no less intense: "They forget that one can only achieve equivalences; it is not the thing itself that must be created but the semblance of the thing."

Delacroix's stroke is definitive. To quote Théophile Sylvestre, one of the few men who understood him during his lifetime: "It combines the amplitude of forms with the feeling of life." More rapid than intellectual processes, his pen or pencil went straight to the essential, in such a way that we even admire those apparent inaccuracies that for so long made him the object of scorn among critics for whom neatness, prettiness, and finish were the only criteria in art. "I only began to do something passable," wrote Delacroix, agreeing in this with Ingres who treated details as minor annoyances, "at the moment when I had sufficiently forgotten small details and remembered only the striking and poetic aspects for my pictures; up to that point, I was haunted by the love of exactitude that most people take for the truth."

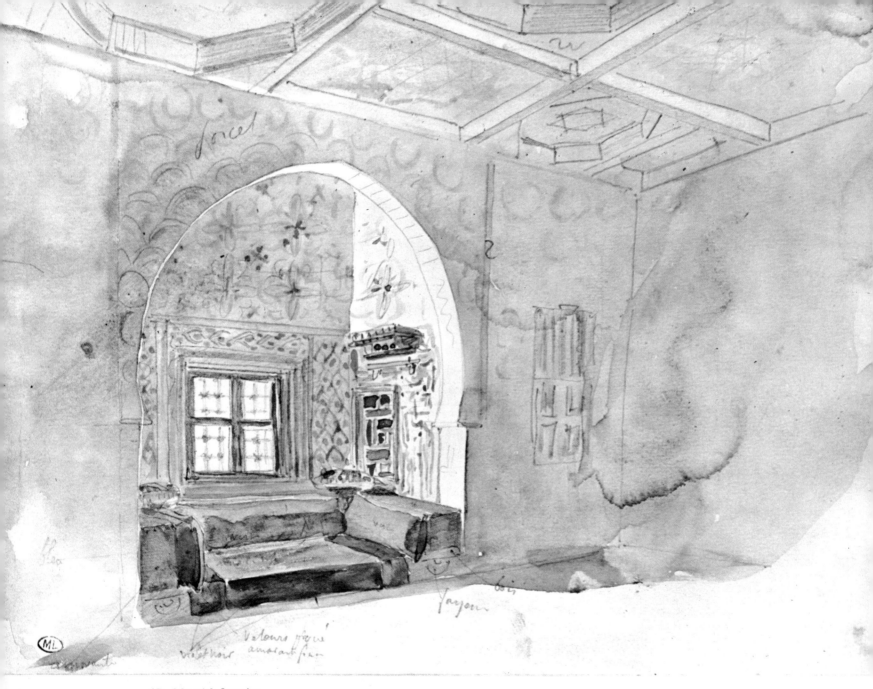

17. Moorish Interior
 Watercolor, page from a sketchbook

 Louvre, Paris

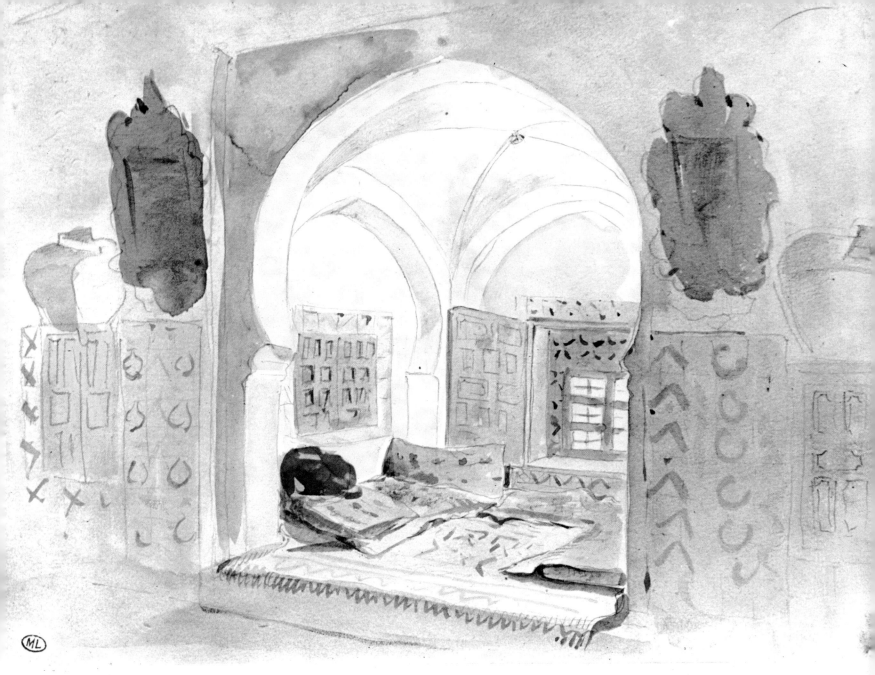

18. Moorish Interior
Watercolor, page from a sketchbook

Louvre, Paris

33

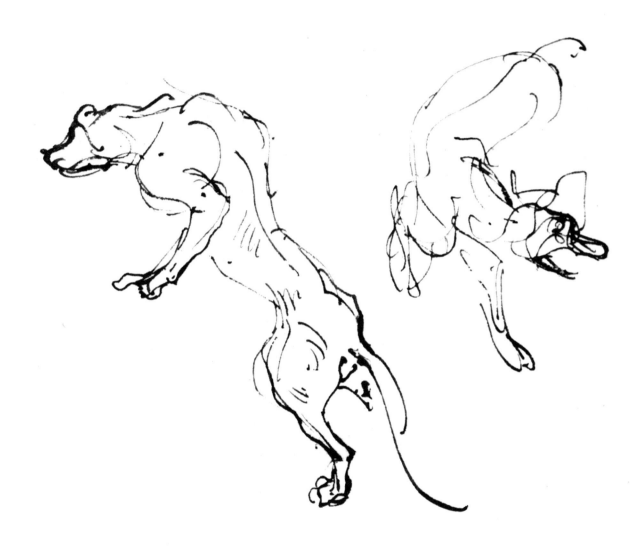

19. Sketch of Dogs
 Pen, from a page of studies

 Louvre, Paris

20. Combat Between a Tiger and a Alligator
 Pen, from a page of studies

 Louvre, Paris

34

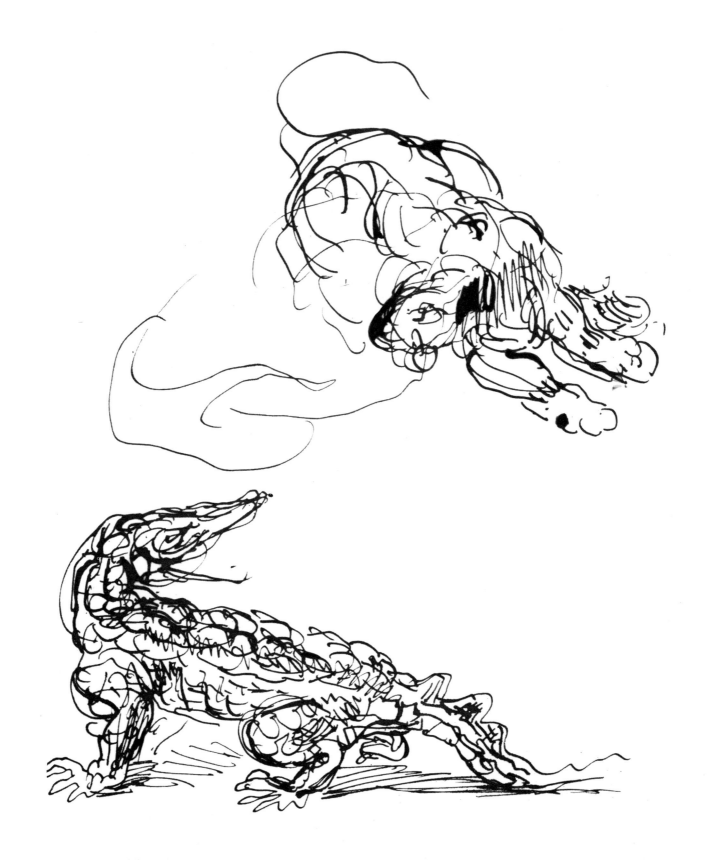

The Daily Prayer

Delacroix called drawing his "daily prayer." From the time that he was eight years old, according to one of his biographers, he drew with a stubbornness that bordered on fury. His recently found school notebooks are strewn with pen and ink sketches, and already his handwriting, both in the artistic and graphological sense of the word, asserts itself with decisiveness and boldness.

"He had a passion for notes and sketches and gave himself up to it wherever he happened to be," writes Baudelaire. Almost every page of the *Journal* bears witness to this profound need to capture everything or, to use a word that he was fond of, to "draw" incessantly from the dictionary that is nature. Opening the *Journal* at random: "I go to the bank of the river and do a sketch. ... I bring back a bouquet of water lilies and sagittaria" (August 12, 1858). And the next day: "I set out again at the same early morning hour on the walk I took yesterday. I stop before reaching Bayvet's fountain to do a sketch that I regretted not having done the day before. It's one of the best in the little notebook that I brought from Plombières." Throughout his life, whether it was at Champrosay, Valmont, Dieppe, Frépillon, Nohant, in the Charente, the Pyrenees, or Alsace; whether it was accompanying Barye to the Jardin des Plantes, visiting a museum, spending New Year's Eve with his friends, or venturing afar to England, Morocco, Belgium, or Holland, this sedentary man never forgot to bring back indispensable mementos of the painter. To these notebooks, he confided his reactions. Leisurely reflections alternate with cursory notations, as in the small albums left to us by Corot, Millet, Jongkind, Boudin, Carpeaux, Redon, or Rodin. Nothing is more alive than these intimate little books; one goes from lists of household expenses to a model's address, from a landscape sketch to the analysis of a flower. Sometimes they are only simple bound laundry lists or black cloth-covered account books in which this genius has hastily set down magnificent signs. How unfortunate it is that in our time painters seem to have lost the habit of having these familiar notebooks forever within reach of their hands.

Delacroix's notebooks are far better than mere reference works. They are, as has been said of the collections of Claude Lorrain and Turner, though in a different context, books of truth. Most of these notebooks have been dispersed, particularly those which allow us to reconstruct day by day, almost hour by hour, his trip to Morocco. A few of them were acquired intact by the Louvre (thanks to the Moreau-Nélaton donation) or by the Musée Condé in Chantilly. Several private collections have fortunately been able to preserve a few others.

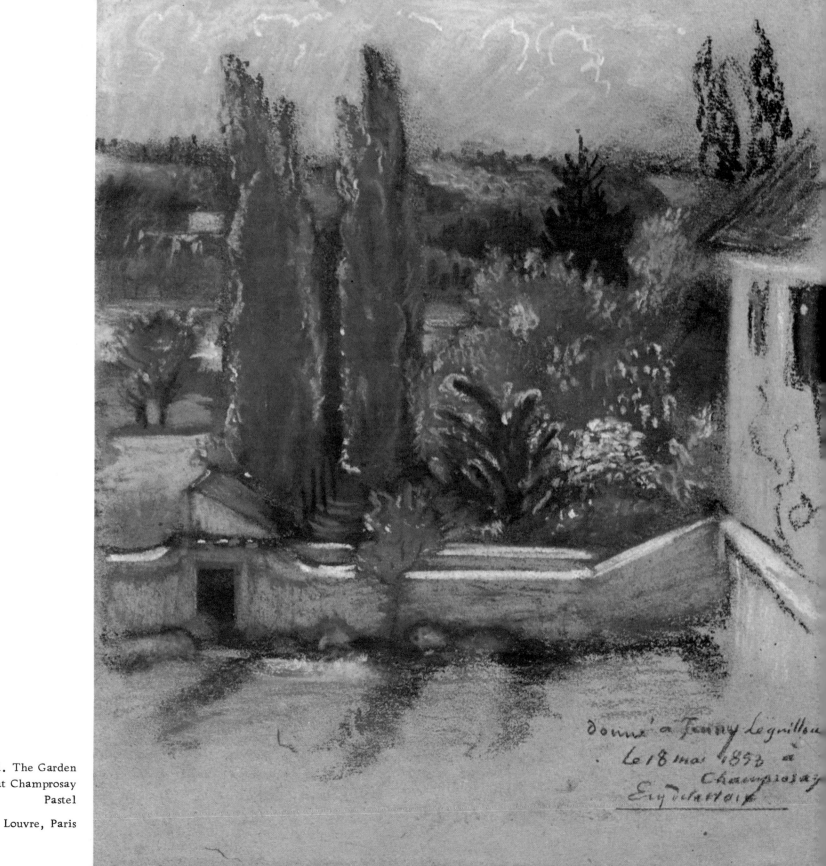

donné a Jenny Leguillou
le 18 mai 1853 à
Champrosay
Eug Delacroix

21. The Garden
at Champrosay
Pastel

Louvre, Paris

Inspirations and Influences

The gathering together of Delacroix's paintings and drawings during the great exhibition organized by the Louvre in 1963 has made it possible for us to follow, year by year, the evolution of his style and the influences to which he was subject, above all, those of his early youth. The influences of the old masters and his friends were basically rather superficial, for, like Rembrandt, he hardly drew differently at sixty than at twenty, remaining always faithful to his graphic sensibility.

Four undeniable influences marked his beginnings: that of R. P. Bonington—there are drawings on which we know they collaborated—that of Theodore Géricault, and that of their two great predecessors, Pierre-Paul Prud'hon and Francisco Goya. We know some of the artists he admired through the studies he published in the *Revue de Paris* on Raphael, Michelangelo, Puget, Prud'hon, Gros, Poussin, and Charlet. He was continually tormented by the same problems. If he reversed some of his judgments, notably with regard to Géricault, seven years his elder, he more frequently retained his first convictions. The author of Des Variations du Beau rarely altered his opinions. Yet despite his cult for Raphael—for the ease with which the latter "converses with the gods"—he was able to write at the end of his life: "Perhaps we will discover that Rembrandt was more naturally a painter than Perugino's studious pupil." Again, in 1857, he wrote concerning Poussin, whom he had always considered one of the boldest innovators in the history of painting: "Sometimes I want to toss him out of the window, sometimes I come back to him furiously or, at other times, in a more reasonable manner."

Along with Titian and Veronese, Rubens remained his true idol. When still quite young, Delacroix had learned to venerate him through Antoine Jean Baron Gros, "who elevated modern subjects to the ideal" and who reacted against "ways of dying, of falling, of cursing, that one learns at the Academy," and "dared to create corpses and feverishly ill men that were true to life." Had it not been for Gros, he almost certainly would never have painted *The Massacres at Chios*.

Nor was Delacroix ever to forget the shock that he experienced when he first confronted Géricault's *The Raft of the "Medusa"* (1818, The Louvre, Paris). He practiced the productive exercise of making copies, following the example of Géricault and Rubens about whom he said, "When he copies Leonardo da Vinci, Michelangelo or Titian, he seems to reveal himself as more truly Rubens than in his original works."

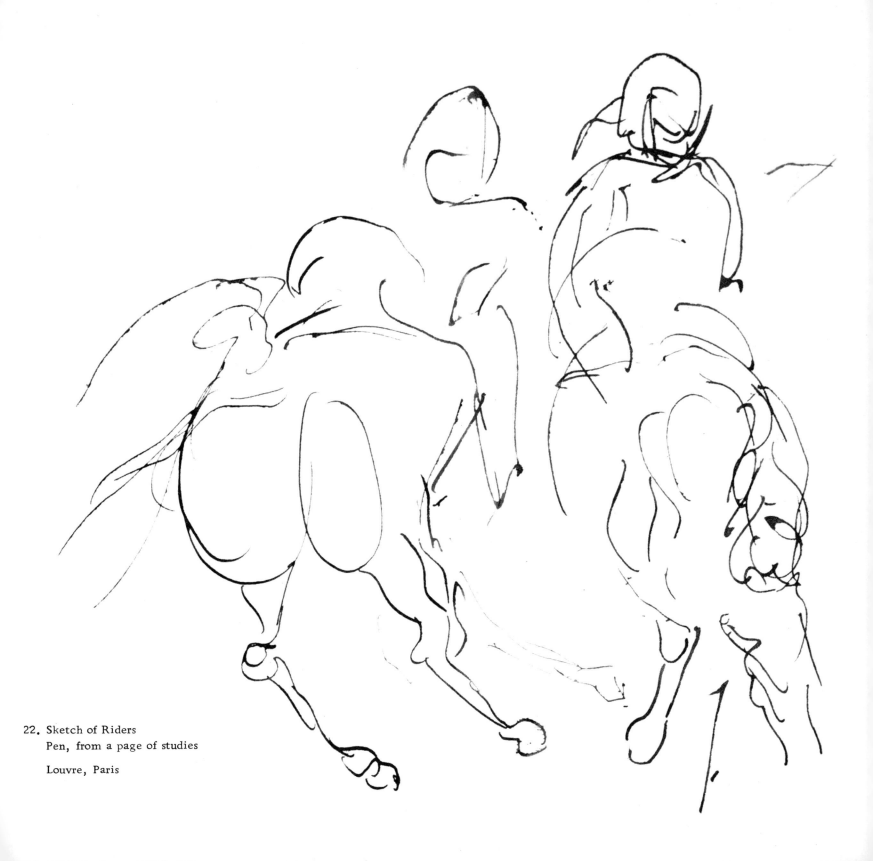

22. Sketch of Riders
 Pen, from a page of studies

 Louvre, Paris

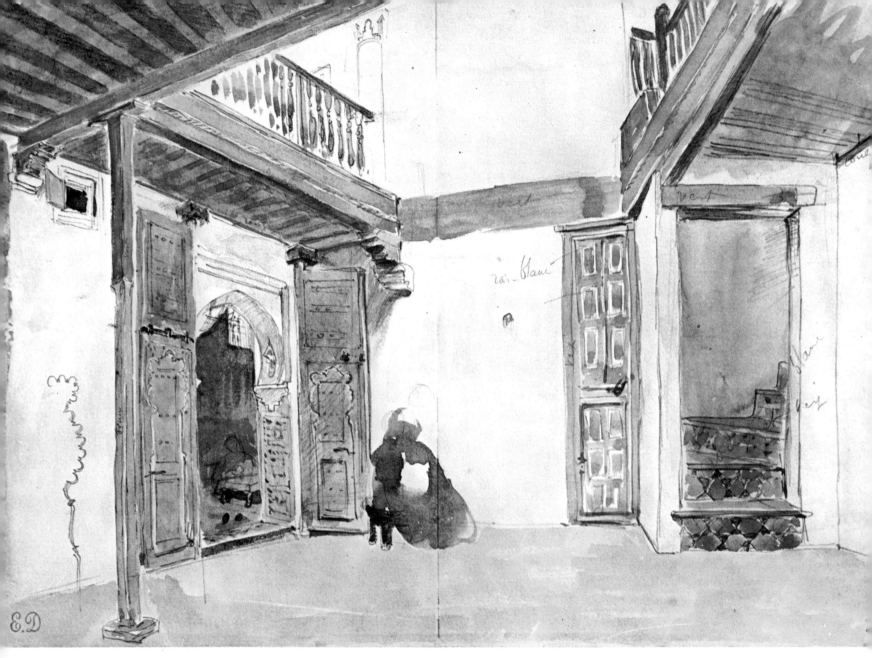

23. A Courtyard in Tangiers
Watercolor

Louvre, Paris

These copies, on either canvas or paper, were done after the original works or from prints that were more or less faithful to the German, Italian, Flemish, and English artists, or those disparaged eighteenth-century masters, Watteau and Prud'hon. He initiated himself into the art of etching when, at the age of twenty, he did two prints after Rembrandt's *Resurrection of Lazarus* and *Abraham and Isaac.* He was obviously thinking of Goya in an early aquatint *(Hospital Scene)* before he found in lithography a technique more appropriate to his temperament, with the masterpiece of 1824, *Macbeth and the Witches.*

Baudelaire has explained that Delacroix "had two very distinct manners of copying. The first was free and broad, a mixture of fidelity to and betrayal of the model, and into this he put a great deal of himself. In his other manner, he made himself the most obedient and humblest slave of his model." At his death, numerous "interpretations" were found in his portfolios, often executed from tracings. On many occasions, daguerreotypes of nude women were the sources of drawings which were later to help him in painting odalisques from memory *(Figs. 8, 48).*

He was never to forget his dear friend Bonington, who, along with the Fielding brothers, encouraged him in the practice of that "English novelty," watercolor. Concerning Bonington, he wrote that no one before him had possessed that lightness of touch that made his works "jewels which please and delight the eye independently of all subject matter and all imitation."

We know the importance his journey to England in 1825, undertaken five years after Géricault's, was to have for him. Constable had already offered an important technical revelation in Paris; it has been said that Delacroix repainted sections of *The Massacre at Chios* after having seen the *Hay Wain.* In London, he was to meet Sir Thomas Lawrence, whose temporary influence can be seen in a number of his early portraits. Tremendously excited by a performance of Goethe's *Faust*, on his return to France he published his first set of lithographs inspired by a literary masterpiece.

Just as his broadly rendered copies permit us to follow his *tête-à-tête* with his gods and the profound communion that exists between their works and his, another fusion, no less rare, unites him to the playwrights and poets—to Dante, Shakespeare, Torquato Tasso, Walter Scott, Goethe and Byron. To the end of his days, they dictated his subjects. Unconcerned with literal illustration, he "was ignited," as he says, by their contact. They did not serve him as cold pretexts but rather as passionate themes with their movement, their light, and their concentrated tragedy. It is in the same spirit that he turned to the Bible or to ancient and modern

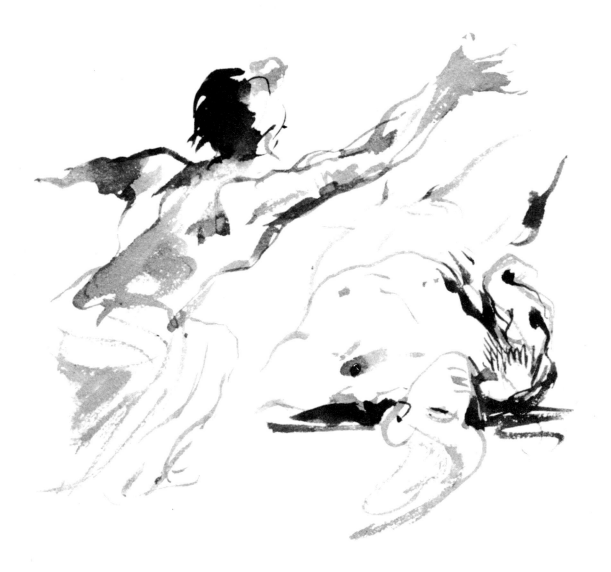

history—not as an archaeologist, encumbered like Ingres by petty exactness, but as a visionary. This visionary could permit himself everything, armed as he was by the passionate liveliness of his eye which sustained him to his last day. He knew how many chain links make up a coat of mail, how many petals a given flower. He knew twenty forms of belts and boats and clouds; he recognized the difference between the Jew and the Berber, just as he knew how not to confuse the subtlest and most elusive nuances. Let us look at the immense booty that he brought back from the journey to Morocco, which we cannot stress too much since it influenced his whole life.

The Moroccan Journey

On January 11, 1832, the *Pearl* set sail for Barbary, as it was then called, carrying a French mission commanded by the Count of Mornay. Delacroix could not resist the offer that was made to him. For a long time, the Orient, taking the word in its most miraculous sense, had worked its magic on the painter of *Greece Expiring on the Ruins of Missolonghi* (1827, Musée des Beaux-Arts, Bordeaux). This Orient, like the Coriolis that the Goncourts invented in *Manette Salomon*, "he loved to inhale in the things that came from across the seas, bringing the color and breath of the East." A friend who had taught him the use of pastel, M. Auguste, had lent him costumes of Turks and Palikars, in which he painted several of his friends. Like Géricault, he copied Persian miniatures. Finally, could not Delacroix himself, with his swarthy coloring and his feverish look, pass for a brother of one of those flamboyant Moors to whom France was sending an emissary? Thus the man who was never to visit Italy received, at the age of thirty-four, a lesson as dazzling as that of Venice or Rome. Unable to keep a detailed record of his trip, as desired, he wrote instead to his friends Pierret and Villot.

"Tangiers. ... we disembarked amidst the strangest people. ... At this moment I am like a man who is dreaming and who sees things that he fears are going to escape him. ... Rome is no longer in Rome. ... You will never believe what I shall bring back because it will fall far short of the truth and nobility that is here. Antiquity has nothing more beautiful. ... Imagine, my friend, what it is to see, lying in the sun, strolling in the streets, or repairing shoes, men who are like consuls, each one a Cato and a Brutus, who even possess that disdainful air that the masters of the world should have. ... The heroes of David and company cut a sad figure with their rose-colored limbs next to these children of the sun.

Delacroix's memory helped amplify his sensations to such a degree that one wonders if, in the final analysis, Africa was not one of his greatest passions. Much later we hear him say to Théophile Sylvestre: "The appearance of this country will always be before my eyes; the men and women of that powerful race will move in my memory as long as I live; it is in them that I truly found ancient beauty."

It was by means of hundreds of notes drawn from life and later, by painted compo-

25. In Meknes
Watercolor, from a page of a sketchbook

Louvre, Paris

sitions, that this great visionary was to enlarge upon his voyage. Lacking his visual memory, many lesser painters were to weaken their first impressions in paintings done from memory and, betrayed by an insufficiency of means, fall into theatricality. Fantasias, Jewish weddings, odalisques, and oriental dances became conventions

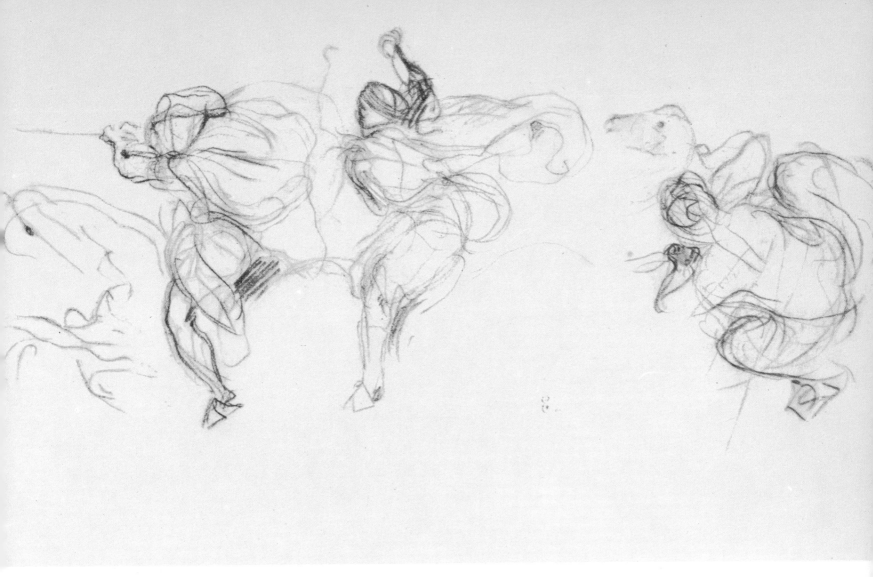

26. Study for a Fantasia
Red chalk

Louvre, Paris

that, following in the footsteps of Decamp, Eugène Fromentin, Marillhat, and Dehodencq, would be divided among the specialists of "orientalism." If Delacroix never sacrificed to a facile picturesqueness, it is thanks to his notebooks and albums, those incredibly brilliant witnesses to his brief stay.

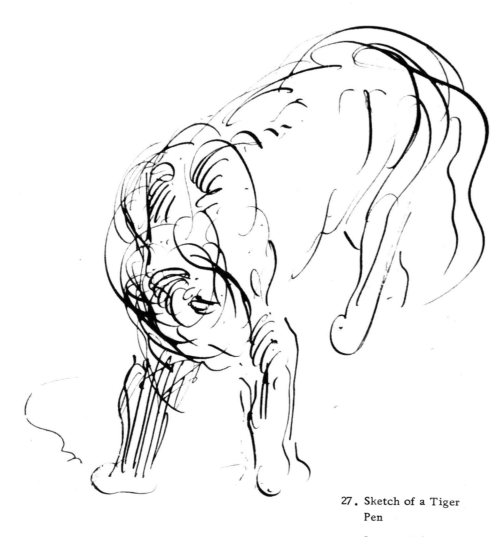

27 . Sketch of a Tiger
Pen

Louvre, Paris

He drew every day in spite of obstacles and fatigue; he persevered whether it was when moving, on the pommel of his saddle, or at resting places in the shadow of fig trees. One day he was able, for some small change, to induce Jews, merchants, and blacks to pose for him in the rooms of the consulate but most of the time, harassed by the insults of a population hostile to the representation of the human countenance, he had to work while concealing himself. With great rapidity, he took note of types as well as poses, movement as well as color, architectural details *(Figs. 17, 18, 23)* as well as the names and particularities of a costume (caftans, burnooses, haiks) or a piece of armor. Musicians, dancers, horsemen, tribal chieftains, water carriers, Turks, blacks, Berbers—all come passionately alive on these pages *(Figs. 14, 46)*. He was no less sensitive to the unfolding of landscape; in the saddle and aboard ship he recorded the coasts of Africa, the walls of Meknes *(Figs. 25, 49)*, the outskirts of Tangiers *(Fig. 15)*, and the shores of Gibraltar.

These drawings, in pencil or pen and ink, are often accompanied by a short commentary, such as, a tone that he did not have time to set down. Dazzled by reflections of light and heat and "harassed," as he says, "by the long rides on horseback, the swimming across rivers amidst gunshots and all the emotions of a life of adventure," this man of delicate appearance still found the strength in the evening, in the silence of his tent while everyone slept, to complete these studies and heighten them with watercolor. He felt that he must not lose anything of such an experience, from which so many future works would benefit. After exciting adventures in Meknes, Tangiers, Seville, Cadiz and Oran, Delacroix returned to France in July, 1832, to find the *Pearl* quarantined in the harbor of Toulon. He took advantage of this enforced sequestration to organize his notebooks and to execute, as a gift for the Count of Mornay, eighteen great watercolors after his sketches, which unfortunately were dispersed in 1877. With Delacroix, no other revelation can possibly compare with that of Morocco *(Fig. 28)*. How can it be that, given his love for the Venetians, he contented himself with admiring and copying them at the Louvre, without venturing across the Alps? Furthermore, one cannot draw a parallel between this journey and the short pilgrimage that he made to see Rubens' work in Belgium. What wonderful notes he made from the *Descent from the Cross* in Antwerp or other masterpieces of the same school! Very soon afterward, however, he felt that he had to avoid all dissipation of his forces and all loss of time. From then on, it would be his responsibility alone to realize his convictions.

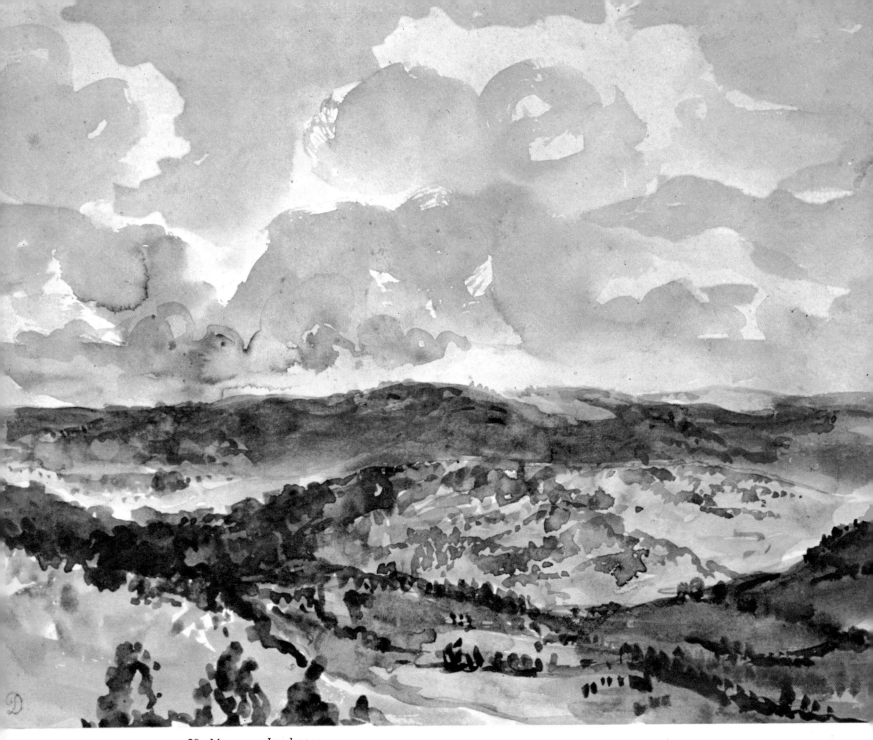

28. Moroccan Landscape
Watercolor

Louvre, Paris

Visual Memory

It is most fitting to emphasize the exceptional gift for visual memory that Delacroix shared with the masters—Rembrandt, Corot, Jongkind, and Redon—this talent which, lacking daily exercise, apparently is declining in our time. Delacroix lived life violently, losing nothing of what he had experienced. Like Corot he was able to say, "I retain in the depth of my heart the memory of all my works." As we have noted, he continually consulted nature but could write: "The model must never be a tyrant. Only those who can do without the model can profit from it. Does one imitate with a view to pleasing the imagination or in order to satisfy a most peculiar kind of conscience which, for many artists, consists in their being content with themselves if they have copied the model before their eyes as exactly as possible?" For instance, how many sketches from life had been executed by lamplight, at those famous musical New Year's celebrations? In the solitude of night, subjects such as men, trees, horses, and lions came alive again with greater freedom and took on fabulous proportions. The ability to capture the figure of a man, in, as Delacroix said, the time that it takes him to fall from the fifth floor of a building, was accompanied by a gift that was no less precious : the capacity to sacrifice details in order to attain a more durable reality.

Ink, pencil, brush and wash—all media were equally valuable to him. Whether he drew by contour alone, by hatching, or in flat areas, splashes, or egg-shaped forms, we recognize him even without a signature, by virtue of his vehement, feverish stroke. As opposed to those protean painters who make us wonder when they are really being themselves, Delacroix appears whole in the least of his sketches. The *élan* of his pen or pencil has always defied the forger.

He was able successfully to carry out his vast decorations because of his power to work from memory, a faculty that his unrelenting rival, Ingres, totally lacked. Moreover, in order to escape all arbitrary stylization, he could always draw upon the immense reserves that he had accumulated day by day, whenever he felt the need of it or when he had some lapse of memory.

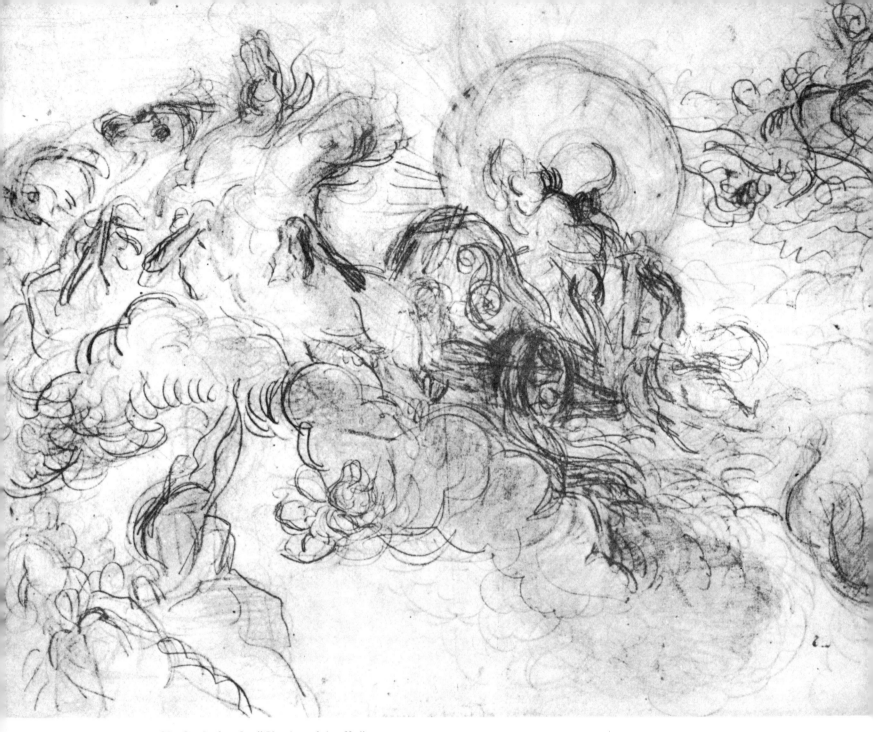

29. Study for the "Chariot of Apollo"
 Black lead

 Louvre, Paris

The Great Decorative Cycles

Discussed, misunderstood, and protected in high places—the mystery of his origins has never been elucidated—when he was commissioned to decorate the walls of the Chamber of Deputies, the Senate, and, later, in 1850, the Gallery of Apollo and the Chapel of the Holy Angels, it was with as much anguish as exaltation that he accepted these perilous honors *(Fig. 29)*. These undertakings would permit his imagination, always more at ease with large surfaces, to prove its range. On the other hand, he would have to submit to the demands of a predetermined frame and surmount all kinds of difficulties, including the fatigue that resulted from spending long hours perched on the scaffolding. If he often requested delays from the administration, it was because, unlike most of his colleagues, he was incapable of being satisfied by superficial work and hastily brushed-in maquettes. How many obstacles there were between the conception and the execution, and in the conception itself, how pressing were the demands of his conscience! Not that he ever felt without resources. On the contrary, the difficulty was rather to choose between a multitude of equally satisfying solutions.

The innumerable preparatory studies for these great decorative cycles were drawn by the artist in his studio, alone with his dreams; nevertheless the inspiration and assurance with which they were executed equal that of his work in the field where he was able to consult nature at his leisure.

The invaluable catalogue drawn up by Alfred Robaut a few years after the posthumous sales show the extent of Delacroix's preparations (often with the help of pupils such as Louis de Planet and Andrieux) before attempting a definitive work. The catalogue often groups together related or individual drawings in lots of twelve to twenty pages. From these groupings we can reconstruct the genesis of all the vast projects, better appreciate their progression, and admire Delacroix's supreme mastery in extracting from his conscious achievements the discoveries of the unconscious by dint of trial and error.

Monumental decorations were to give him the opportunity to unite, in a great synthesis, all those formal elements he had collected for so long. Whether it was a river that he needed, or a plain or a tree *(Figs. 2, 4, 5, 7, 15, 31)*, a cloud *(Fig. 16)* or a flower *(Figs. 32, 33, 47, 51)*, a costume or a piece of armor *(Figs. 14, 46)*, he was never in the position of those far too numerous mediocre artists who found it necessary to draw from a storehouse of accessories or theatrical decor or who borrowed backgrounds from one canvas

or another to provide a setting for their figures. The gestures, the expressions, the stormy or serene atmospheres *(Figs. 28, 36)*—all these Delacroix had lived and made his own without even having to consult previously taken notes, for they were engraved in his memory. Moreover, he never presented a disparate series of objects, more or lessingeniously assembled on the occasion of an event taken from history, legend, his readings, or his fantasy. Rather, like Veronese, Tintoretto, Rubens, Rembrandt, Velazquez, and even Tiepolo, whether the scene be sacred or profane, be it the *Women of Algiers* (1834, The Louvre, Paris), *The Entry of the Crusaders into Constantinople* (1840, The Louvre, Paris), *Christ on the Lake of Genesareth* (1854, The Walters Art Gallery, Baltimore), *Christ Carrying the Cross* (1859, Musée de Metz), the hemicycles of the Library of the Palais Bourbon, or *Jacob Wrestling with the Angel* (1856-1861, Church of St.-Sulpice, Paris), a profound unity always relates one element of the composition to another. This unity does not derive only from the harmony between different tonalities that was realized by this painter-musician, nor from his colorist's instinct for attractions and repulsions, nor even from the deep feeling he had for the spiritual correspondence of colors. For if one disregards the color, it becomes clear that the organization of the lines, the values, and the chiaroscuro have already defined the direction of the composition. Thus we cannot attach enough importance to these preparatory drawings which were often jotted down on whatever was at hand (as if he feared that the vision would vanish as soon as it appeared) and whose great merit lies in their definitiveness and their silences as much as their flashes of light, in what they omit as much as what they emphasize.

These drawings are more than promises of the future; they are, and let us not be afraid to insist upon this, viable embryos, even when they are rendered by quick pencil hatchings or splashes of India ink, indeed, even when the contours are not fully articulated, the eye not having time to control the hand. Occasionally, Delacroix attacked the paper so furiously that it was perforated by the point of the pen or pencil. Even when no tones heighten the paper, color is implied, as one can see in this book, where monochrome pages alternate with watercolors. We have endeavored throughout to present Delacroix in his most characteristic and least known aspects, through those works which bear witness to a master as diverse as he is consistent, as spontaneous as he is reflective, as incapable of coldness as of falsity, as committed to his art as he is detached from material possessions and who, shortly before he died, said that in order to execute all the projects which were fermenting within him, he would need several lives.

CLAUDE ROGER-MARX

30. Head of a lion
Watercolor, pencil,
and gouache heightening

Louvre, Paris

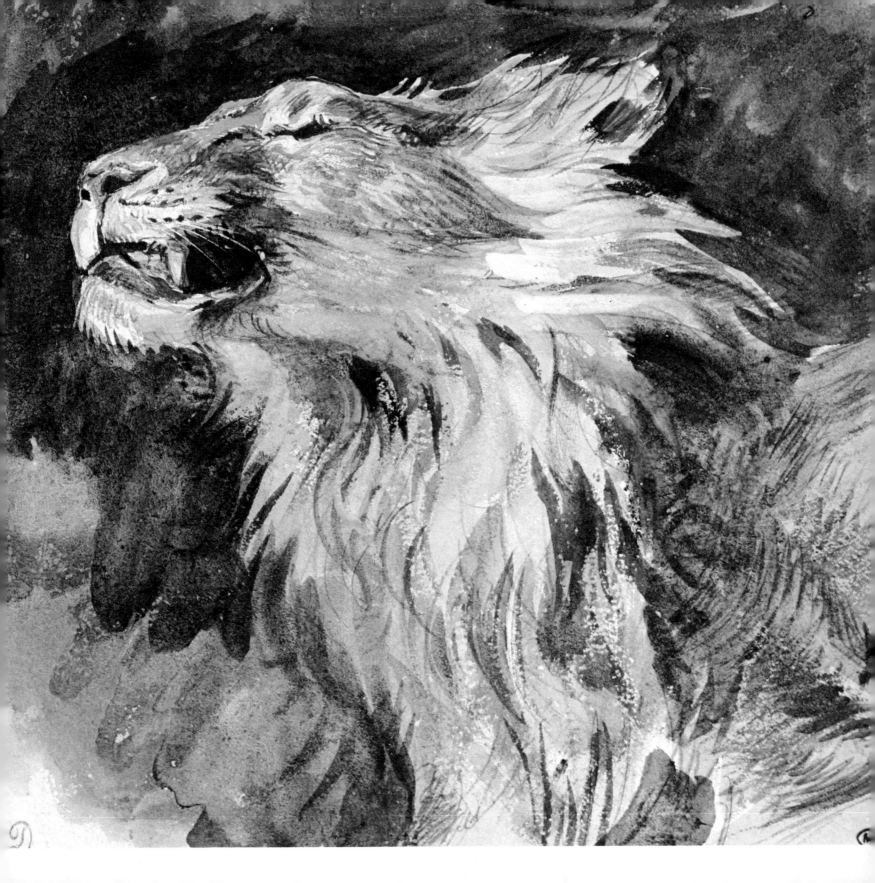

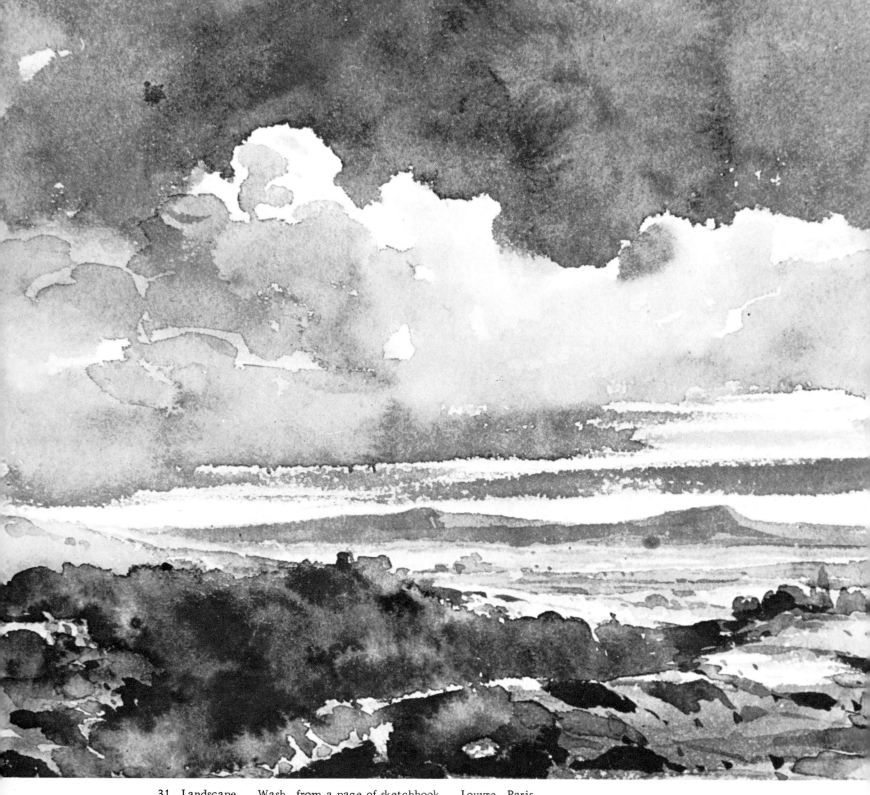

31. Landscape Wash, from a page of sketchbook Louvre, Paris

II

Drawing: An Intimate Journal

Claude Roger-Marx has just interpreted Delacroix the artist and the man. Now it is time to hear Delacroix's own voice, to listen to what only he can tell us. His drawings are another, more intimate journal, through which he confides to us not his reflections on art, but his art itself, already complete, in its nascent state. It is to this birth—the birth of Delacroix's universe—that this book invites us.

What is the first thing these drawings reveal? An imutable dynamism that prevails throughout a lifetime. Another fundamental characteristic that we recognize immediately is the absence of any evidence of chronological sequence. Neither themes, nor technique, nor style, permit us to spontaneously date these works. The adult and the young man inhabited the same universe. To enter Delacroix's world, we are not called upon to follow a hazardous quest, a hesitant investigation, or a laborious construction in which each work rests on the other like the steps of a staircase. These horses and Moors did not have to wait for the Moroccan journey to take form; they already haunt the sumptuous agony of Sardanapalus. What, then, is the origin of these visions? It is in the drawings that we come upon them, catching them by surprise as they emerge with sudden violence. They are the testimony to a mysterious genesis. This initial contact between hand and paper is the first act, the motive force, the primordial gesture.

In this respect, the drawings that are restricted to a few lines, born in the space of several seconds, are perhaps the most richly instructive. They invite us to witness the development of life itself in Delacroix's art. They are the original cell, the embryo that already contains all the genes that will grow, with the passage of time, as the page is filled, further refined, and transformed. This series of drawings makes it possible for us to grasp a whole being, a whole universe, at several specific stages of its development. There is the lightning sketch (*Figs. 22, 27*), the rough drawing completed in a few minutes (*Figs. 24, 55*), the careful study (*Figs. 21, 51*), and the project for which the hours no longer count.

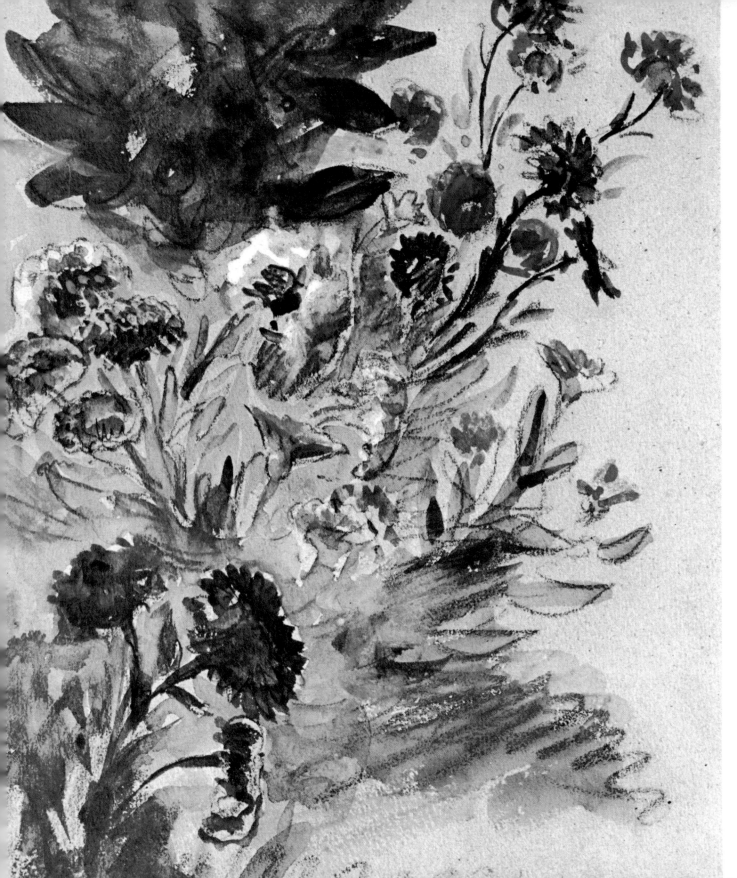

32. Garden Flowers
Watercolor

Louvre, Paris

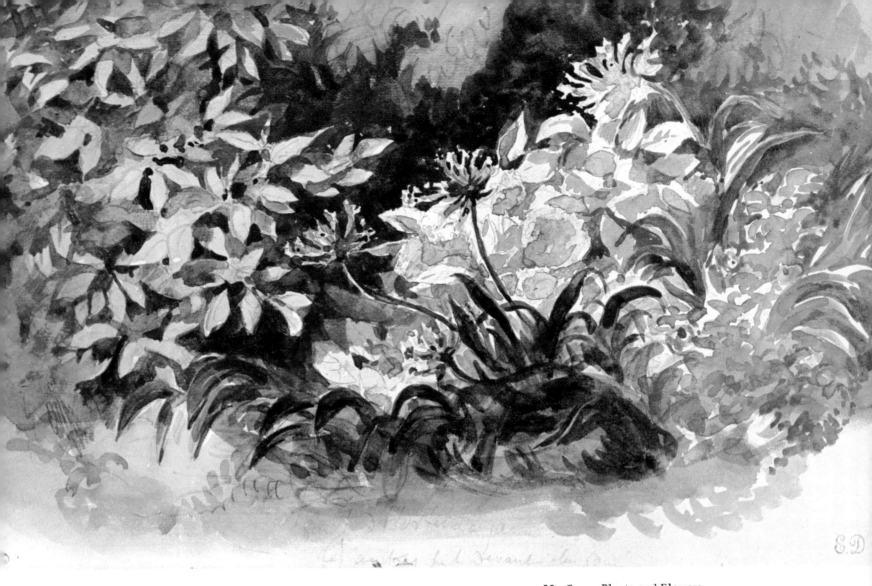

33. Green Plants and Flowers
Watercolor

Louvre, Paris

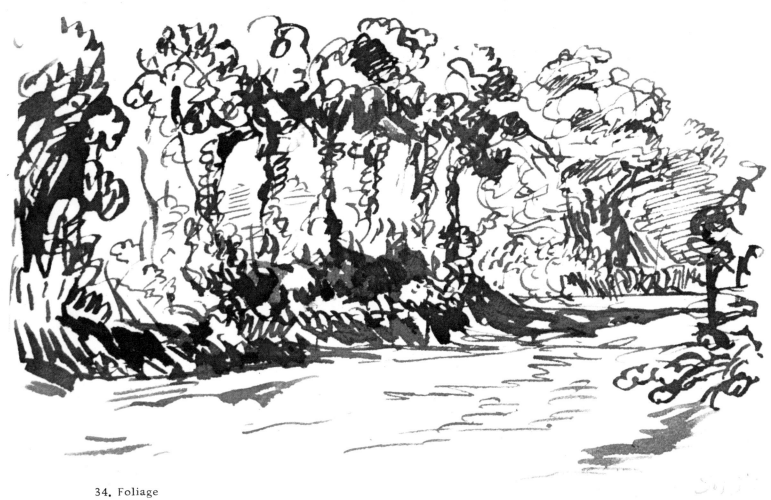

34. Foliage

Pen and wash

Louvre, Paris

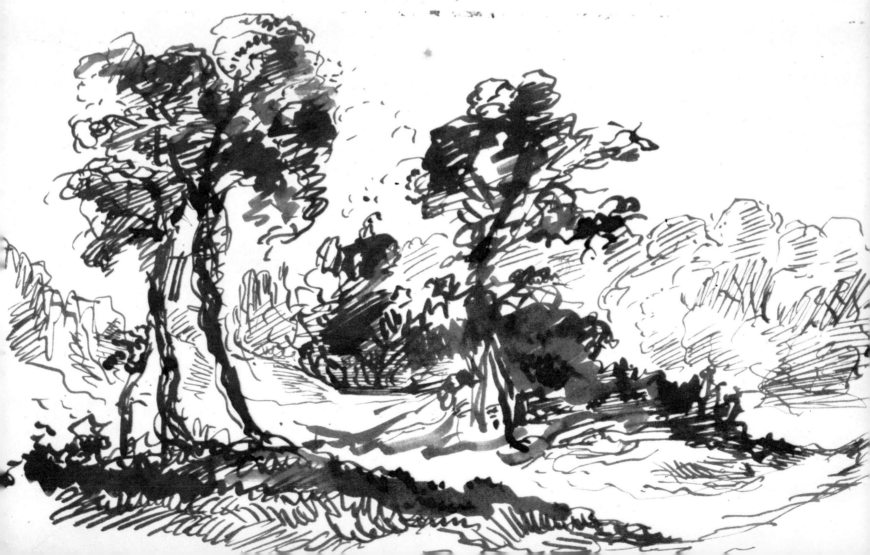

35. Wooded Landscape
Pen and wash

Louvre, Paris

To Be a "Seer"

Thus we shall see how the embryo grows and how the cells divide. This inquiry will allow us to be, quite literally, "seers," to read the future in the present. We will of course be able to see beyond these sketches to the completed *Jewish Wedding in Morocco* (c. 1839, The Louvre, Paris) or to the *Women of Algiers* in their definitive attire. But we will also see—and this is perhaps even more captivating—potential Delacroix's in drawings that one can imagine completed as the *Entry of the Crusaders into Constantinople*. Conversely, and of primary importance since they fulfill Delacroix's own most profound desire, these drawings permit us to constantly rediscover the freshness of the sketch before his most thoroughly finished works and to see in them once more their first youthfulness, the green paradise that lives on beneath their bituminous varnishes.

These multiple stages of development allow us to grasp what is unique and specific in each of his gestures. From the first pen stroke or touch of wash to the final glaze, we are aware of the same internal rhythm, the same dynamic energy.

An understanding of this profound unity is necessary if we are to dissipate the misunderstanding that victimized Delacroix for so long. Throughout his life, his contemporaries accused him of not knowing how to draw. "Slapdash," they said before his paintings. For a period in which Ingres had invented the famous phrase, "Drawing is the probity of art," this criticism was actually an insult. Yet, this supposed specialist in *fà presto* had difficulty fulfilling the commissions he received. His *Journal* and his correspondence reveal that he was continually requesting extensions of time in order to complete his commissions. Is there not a contradiction, a mystery, in this? In this book, beneath our very eyes, we see materialize in a few pen strokes or dabs of color, fleeting sensations caught in full flight. Before the paintings, we are in the presence of a complex world, learnedly elaborate and full of references to a culture that is unfamiliar to most of us. How does this transition from the thing seen to the imagined world operate? How did Delacroix construct a whole universe from simple elements? When, why, and how did he take up his pencil or brush? Finally, what is the value of this gesture which is at the source of a work and from which the work arises in all its richness, complexity, and yet profound coherence?

36. Landscape
Watercolor

Louvre, Paris

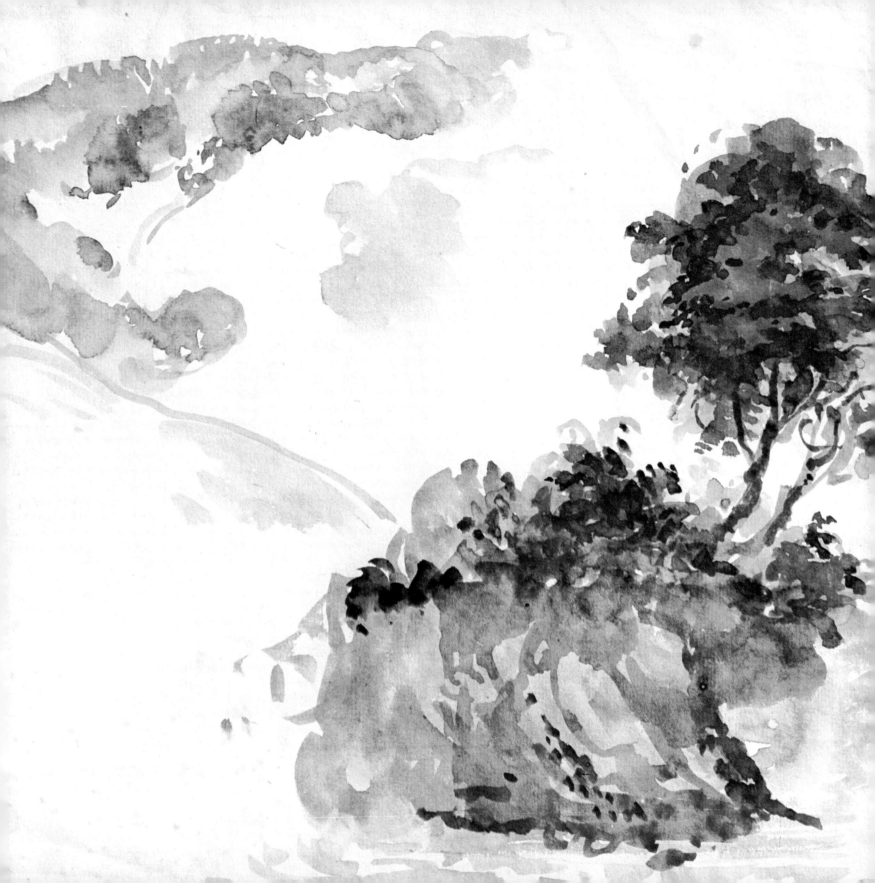

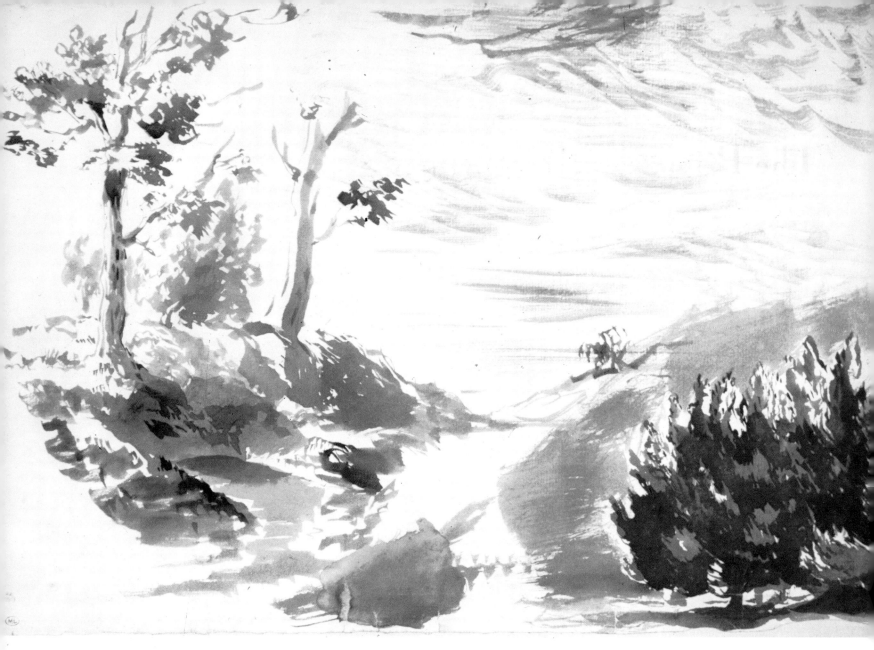

37. Landscape
Wash

Louvre, Paris

The Primordial Imagination

For the answer to these questions, we must again turn to Delacroix himself, to his drawings. Because of their number, their variety, and the importance he accorded them, these drawings constitute an essential part of the total body of his work. They are of very different kinds. Like all his contemporaries, Delacroix considered the visible world as a vast repertory of objects. He thus looked at, observed, and noted, through the act of drawing, all that he had before his eyes. But unlike his contemporaries, he also considered the role of the imagination before reality to be primordial. His ambition was to follow nature without being its slave. That is why the most revealing and personal part of his *œuvre* is to be found in these drawings, done from life or in the studio, that are the subject of the present work.

First of all we note that the least elaborated and the most rapid drawings represent animals for the most part. For example, his sketches of lions *(Figs. 10, 30, 58)* or the sketch of dogs *(Fig. 19)* are only brief notations, summarized in a few strokes. Before these models who do not hold a pose, Delacroix was obliged to condense his impression and to invent a handwriting, a stenography. He took pleasure in darkening whole pages with intricate lines in which the attentive observer will discover horses reduced to a few signs, whose proliferation and superimposition heighten the instantaneous quality of his handwriting *(Figs. 22, 54)*. "It is not form that he studies," says René Huyghe, "but rather its animating principle, its living essence that he transcribes." The line moves nervously, interrupts itself, breaks and shatters into a tracery that vibrates with life to suggest the tensely watchful animal. The pen, saturated with ink, claws impetuously at the paper, as if following the path of its own vitality.

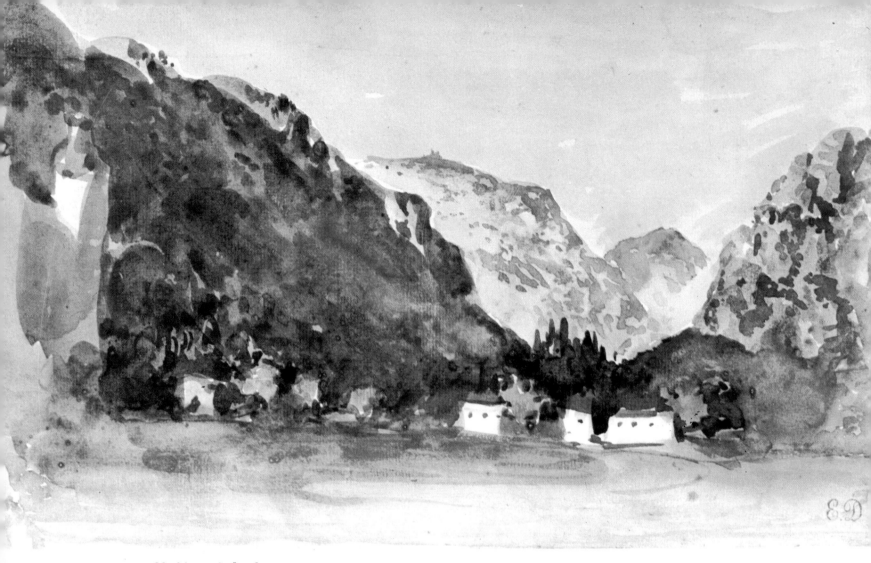

38. Mountain Landscape
Watercolor

Louvre, Paris

The Moment of Genesis

Half-man, half-beast, the rider belongs unquestionably to the animal world *(Figs. 14, 22, 46)*. He shares its power, its freedom, its passion. That is how he appears in the sketch of a rider *(Fig. 16)* or the *Fantasia (Fig. 26)*, triumphant over gravity and incarnating the dream of liberty which is that of all creators. For these drawings, whether from life or not, are far from being mere investigations of nature. In Delacroix's art, emotion was always the essential stimulus. He saw in the animal the expression of an impassioned strength, the symbol of a power that is precisely that of the artist at the moment of genesis. By drawing, he identified with these wild beasts he had so often sketched, whether at the zoo or from memories of Morocco—Delacroix himself was so aptly compared by his contemporaries.

Sometimes he would linger over a drawing in the studio in order to complete a vision only momentarily glimpsed. Thus, for example, he heightened with watercolor the initial sketch of the *Head of a Lion (Fig. 30)*. The animal's coat, illuminated by a complexity of tones ranging from warm blacks and browns to light ochre, is rendered by great colored flames which melt into each other. Certainly, the time it took to execute this drawing was longer than the time required to observe the animal but the artist was able to restore the instantaneous quality of the vision through the freedom of his touch. He preserved the emotion that seized him in the presence of wild beasts, a feeling he confesses to in his *Journal*: "Tigers, panthers, jaguars, lions—whence comes the emotion that the sight of them produces in me?" (January 19, 1847)

It was not always from reality that the artist drew; at times, in the stillness of his studio, far from the demands of the outside world, he created forms of astonishing freedom in which one seems to feel, even more than in the drawings from the model, the fever of the creative act. The watercolor entitled *Tiger Attacking a Wild Horse (Fig. 12)* is a case in point, with its drawing that is primarily suggestive and its force that is, above all, dynamic. This pitiless battle, uniting the two animals in the same swirling oblique, is emphasized by the horse's torsion and his flying mane, as well as by the twilight atmosphere of the landscape. Here Delacroix offers us, along with this profound study of reality, the secret of his creative power: the ability to combine in a simultaneous whole, observation, imagination, and vision.

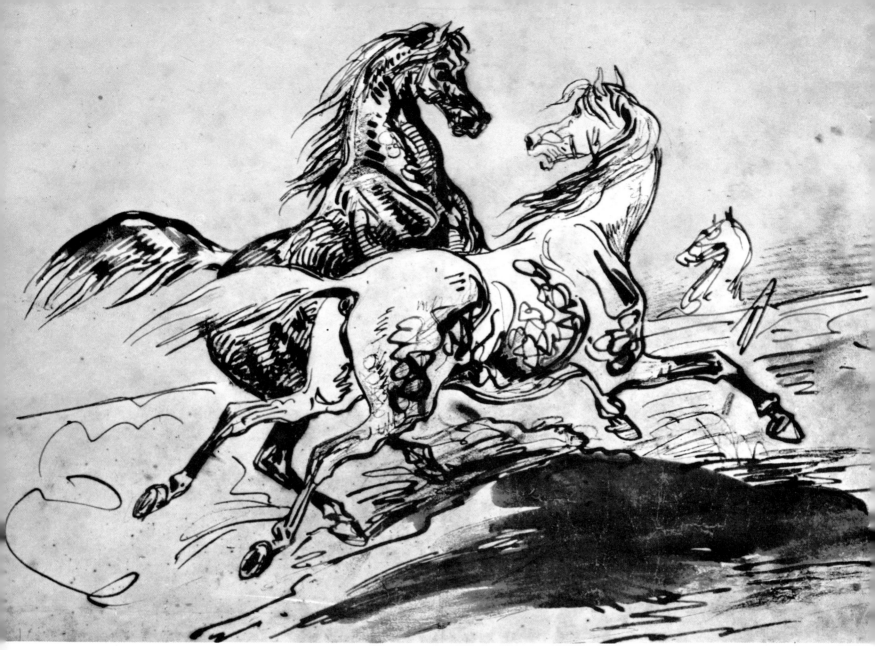

39. Stallion and Mare
Pen and wash

Private collection

Grasping the Ungraspable

If movement constitutes the *raison d'être* of the animal drawings, what, then, shall we say of the landscapes? One might think that here the confrontation with a durable and timeless nature would perhaps have discouraged Delacroix in his continual quest for movement. Nothing of the kind! He found in nature the confirmation of all that he most profoundly sought. In landscape, he pursued that element which is most elusive and full of movement—light.

In order to render this changing light which fragments into reflections and bathes the whole of space, Delacroix preferred to use watercolor or wash. Rejecting line altogether or using it only as a shimmering undulation, he used his brush to cover broad dark areas; he left the white of the paper to suggest light. Thus, in the church whose spire punctuates the horizon with its dark silhouette, a drama is played out in the opposition between the shadows and the pools of light in the foreground *(Fig. 5)*. No line stops the eye and yet the movement, the breathlike pulsations, convey a perceptible space and the illusion of the infinite. The trees, swaying in a fluid and wavy motion, are no longer forms, but are instead rhythms which respond to the curves of the clouds or the craggy roughness of the earth's surface.

Let us listen to Delacroix explain why he sees no lines in nature: "I am at my window and I see the most beautiful landscape: the idea of a line doesn't occur to me. The lark sings, the river shimmers like a thousand diamonds, the leaves murmur; where are the lines that produce these charming sensations?" (*Journal* July 15, 1849) This sense of wonder before nature transcends the sterile Beaux-Arts quarrels or rather, makes the conventions of academic drawing fall like an old and useless curtain. Before a landscape, Delacroix seemed completely liberated from all concern with description. This artist who often used drawing as an aid to memory in order to note the details of a costume, an object, or a building, surrenders himself completely to space and light. The earth, reduced to a narrow band, is present only to exalt the immensity of the sky; the clouds, waging the battle of day and night, anticipate the theme of *Apollo Destroying the Serpent Python* on the ceiling of the Gallery of Apollon in the Louvre *(Fig. 29)*

Imaginary Flights Across a Landscape

When he cast a circular, panoramic look about him, Delacroix became intoxicated with the boundlessness of space. As a young man he discovered the immense horizons of Morocco whose rolling chains of blue or violet mountains unfolded into infinity *(Fig. 15)*. Later it was the great northern plain that was so favorable to imaginary flights, so thrilling in its bareness and its eternal dialogue between earth and sky *(Fig. 31)*. Here Delacroix joined the spiritual family of the great Dutch landscapists, Ruisdael and Hobbema, whose fierce and proud accent he rediscovered. In his flickering lights, his moist and changing skies *(Fig. 40)*, he owed a great deal to Bonington, that artist who brought to France the subtle and atmospheric beauties of English watercolor.

The movement, light, and rhythm that Delacroix found in landscape are the essential elements of his aesthetic language. His vision of reality confirmed for him the creation of his own universe. This synthesis is especially evident in the series of watercolors representing the sea, which were executed on the coasts of Normandy where he frequently visited during his stays in the Château of Valmont. The cliffs of Fécamp and of Étretat offered him the image of rocks constantly transformed by the waves *(Figs. 43—45)*. In this continual struggle between earth and water Delacroix found the same fundamental dynamism of his animal studies. It is not line that translates the movement here, but broken, light touches of watercolor and the turbulent energy of a hand that knew how to capture the swirls of crests and foam. Massive rocks dissolve in the liquid element, matter disintegrates into multiple reflections and transparent color and light.

For Delacroix, landscape was a veritable springboard to the dream; it occasioned the confession of a man devoted to solitude and the inner life. In the pastel called *The Night (Fig. 1)*, the river flows on timelessly, eternally the same, immobile and liquid between the dark and parallel banks. The twilight limpidity of the sky, the dense and mysterious color, the oppressive atmosphere—all contribute to transforming this landscape into the statement of a profoundly spiritual mood.

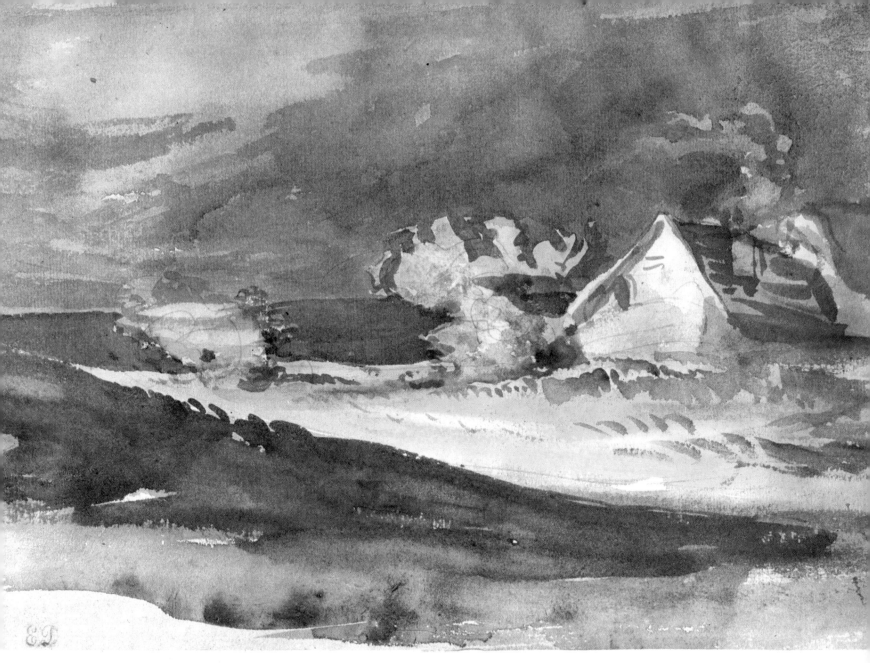

40. Marine Landscape
Watercolor

Louvre, Paris

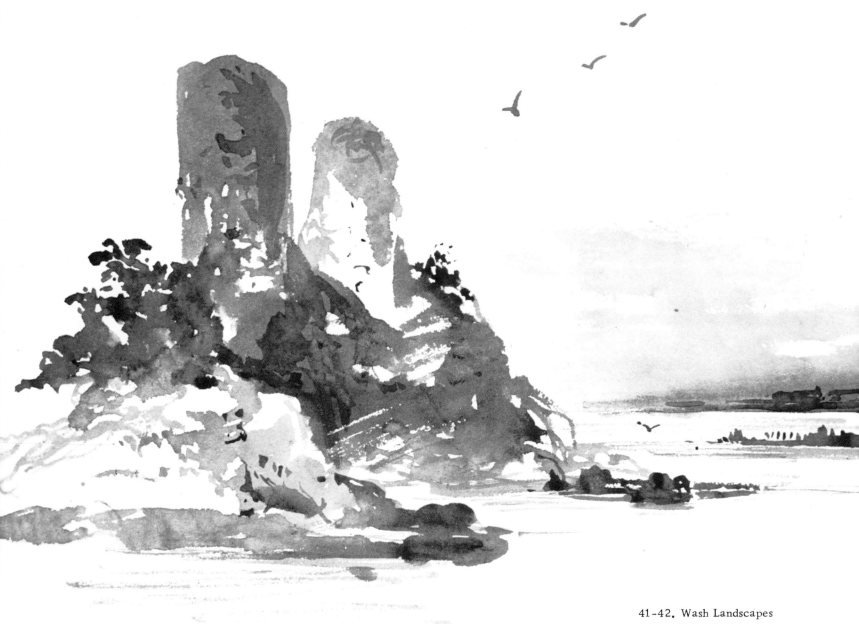

41-42. Wash Landscapes
Louvre, Paris

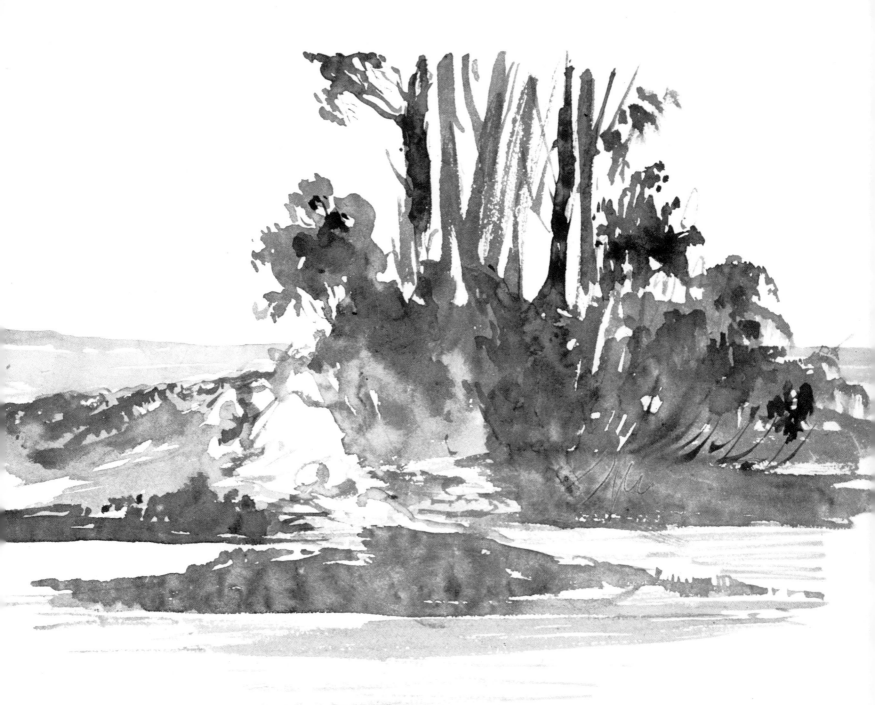

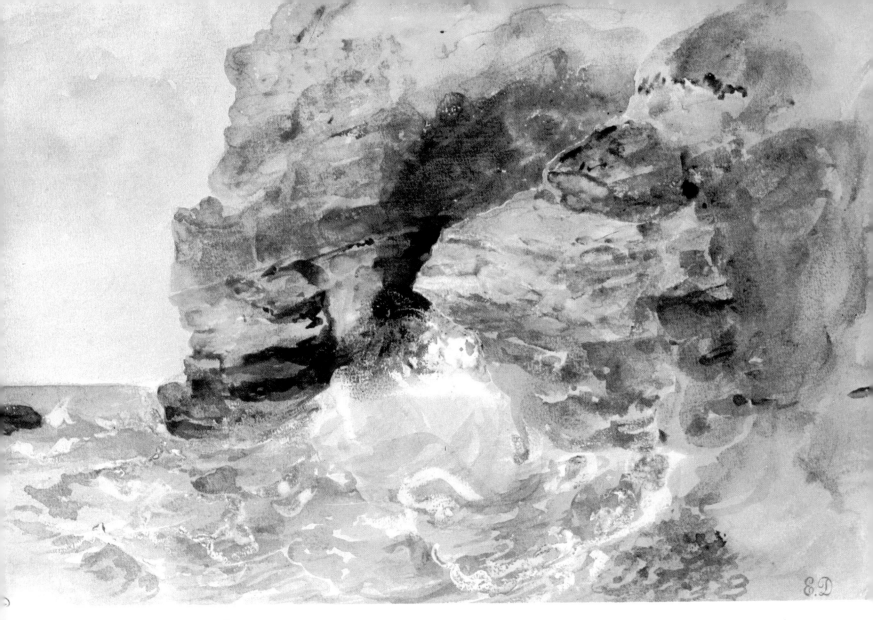

43. Cliffs at Etretat
Watercolor

Louvre, Paris

Intimacy of Nature

What a surprise it is to discover that for the same artist nature had its intimate and familiar side—a nature of the garden that is encompassed with a look, of flowers that are gathered into bouquets. It is an unexpected facet of his art that only a few drawings reveal. Delacroix has left us several views of George Sand's garden at Nohant where he visited several times, but his preferred country retreat was the one that he set up at Champrosay in the outskirts of Paris. He often went there beginning in 1844. The pastel dedicated to his housekeeper, Jenny le Guillou, preserves the memory of this rural setting *(Fig. 21)*. These country sojourns gave him the opportunity to study flowers, as we see from several watercolor drawings *(Figs. 32, 33, 47, 51)*. It was as a botanist that Delacroix undertook the study of plants; in fact, he knew Jussieu with whom he discussed this subject. Either he showed the flower "in situ," on its stem and in an outdoor light, or he observed it skillfully incorporated in a bouquet. He noted the rare color harmonies of these wild flowers and took great care to arrange them well-developed studies in groups so that they might later serve in the creation of his great oil still lifes, most of which are now lost.

These highly elaborate works lead us to another important aspect of Delacroix's drawings, the preparation of his great compositions. Like all his contemporaries, he considered paintings destined to be presented at the Salon and judged by the public as the ultimate goal of all artistic activity. A painter first and foremost, Delacroix made of the great mass of drawings accumulated throughout a lifetime, a plastic repertory that would always be available for the construction of the great composition in oil.

Art and Artifice

From Morocco he brought back not only visions of landscape and a renewed sense of space and color, but also very precise settings in which he would later situate the action of his paintings. The technique of watercolor, laid down in broad luminous touches, lends itself readily to the rapid notation of colors; these he often completed by written notes to supplement his visual memory. The sketch from life freely juxtaposed colors in a manner that is completely modern, whereas the slower oil technique required at that period that colors be fused together by halftones, giving the painting a more sustained general harmony. Thus, we find the *Moorish Interiors (Figs. 17, 18)* modified several years later in the two paintings of the *Women of Algiers*.

The study for the *Martyrdom of Saint Stephen (Fig. 9)* offers an equally revealing example of Delacroix's approach. The landscape which serves as the setting for the action is a recollection of the walls of Meknes, in whose shadow Delacroix had already situated his *Sultan Muley-Abd-err-Rahman* (1845, Musée des Augustins, Toulouse). In the drawing he retains the atmosphere and general coloration of the landscape—deep red and blue-green in the background—while the foreground group is only sketched in grisaille by lightly interwoven lines. Thus, we see that the background creates the general atmosphere of the painting and even conditions the representation of the action itself.

Conversely, in the study for *The Massacres at Chios (Fig. 13)*, the placement of the figures precedes and, to a certain extent, dominates the landscape. It is worth noting, moreover, that for this work of his youth, he increased the sittings with his models (the preparatory work lasted six months), but did not succeed in finishing his painting until he had changed the background. He replaced the rock that in the drawing is erected like a screen with an opening that leads into infinity, a solution at once more real and more dramatic. The vivacity of juxtaposed touches of watercolor in the study has given way to a more dense and affirmative chromaticism in the painting. "Somberness is replacing the confusion that reigned," he noted on May 9, 1824. At the same time, the painting acquired a torsion, a strange movement: "Though it may lose in naturalness, it will be more fruitful and more beautiful" (*Journal*, May 7, 1824). Art is artifice, implies Delacroix, and later he underlines this constant exchange between the real and the imagined: "Sometimes an idea dominates the form that corresponds to it, sometimes the form, the consonance determines everything."

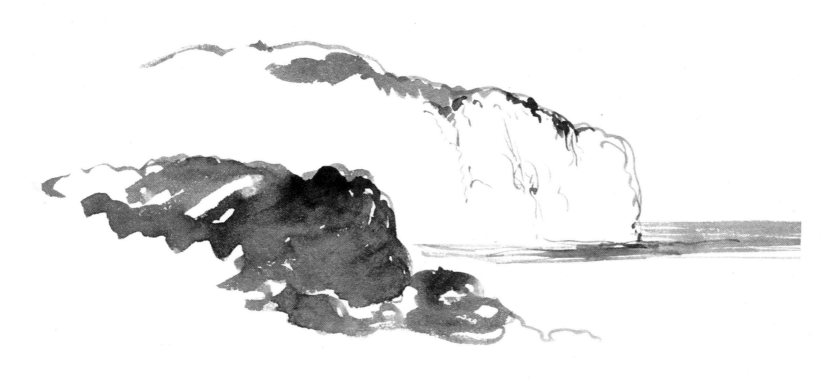

44. Cliffs

Wash, from a page of studies

Louvre, Paris

In preparatory drawings for the great compositions it is unquestionably the idea which governs the form: the sinuous twisting that is so unnatural and so moving in the female nude for the *Death of Sardanapalus* is a pure vision *(Fig. 8)*. No model could have taken such an intricate pose. Yet, certain details are true to life; the left foot in its slipper and the flowing dark hair are borrowed from other studies drawn from a model. The definitive form is the product of associations. "What does it mean to compose? It is the power to associate. . . ."

The Wedding of Dream and Nature

Visions or models? Nature or imagination? To create or to copy? To all these oppositions, to all these classic dilemmas, Delacroix's drawings supply a radical solution. They do not answer directly—they do better, by showing the absurdity of such problems. In all phases of their development, they make apparent the interweaving of dream and reality, perception and imagination. For Delacroix the imagination is the condition that makes perception possible. His dream prepares for the advent of the real, anticipating its basic structure. However, without the nourishment provided by nature, without this contact with nature, the imaginary could not take form. Without the dream, nature would remain blind; without nature, the dream would be hollow. It is to this wedding of dream and nature that these drawings invite us.

We have discovered nature astonishingly fresh and youthful in these limpid watercolor pages that the Impressionists would not have repudiated. Intense and full of movement, this dream of a strange, passionate world surges with the memory of "poetic thoughts and feelings already known, but that one believed forever buried in the night of the past." In this wedding lies Delacroix's greatness, but also his fragility. It represents the last attempt at a union between humanistic culture and observed reality in Western art. After Delacroix will come the divorce. Nature will dissolve into the *Nymphéas*, pure imagination will take flight in abstract art. Delacroix's is a threatened universe, one which feels its end approaching. These drawings betray the frenzy, the vitalistic exaltation, redolent of death, that intoxicates Sardanapalus. This breathless calligraphy, this desperate dynamism, is like an accelerated film of a whole cultural tradition that passes before us at the ultimate moment of its disappearance. In this perspective, each convulsive line becomes even more moving. This haste, this torsion, is not only that of a man's hand. It is that of a universe at its end.

SABINE COTTÉ

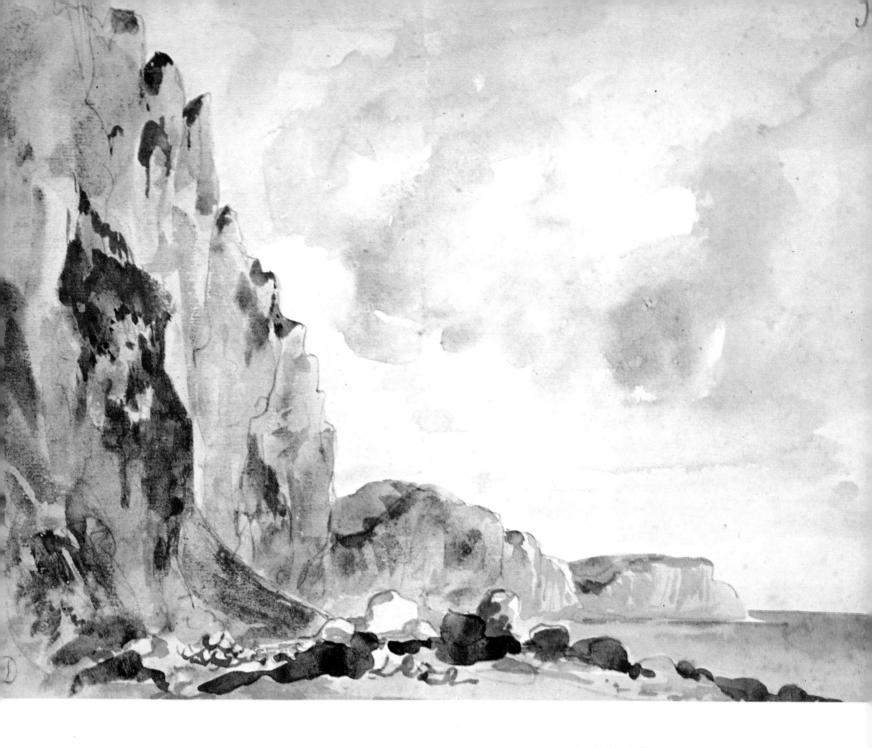

45. Cliffs at Etretat
Watercolor

Private collection

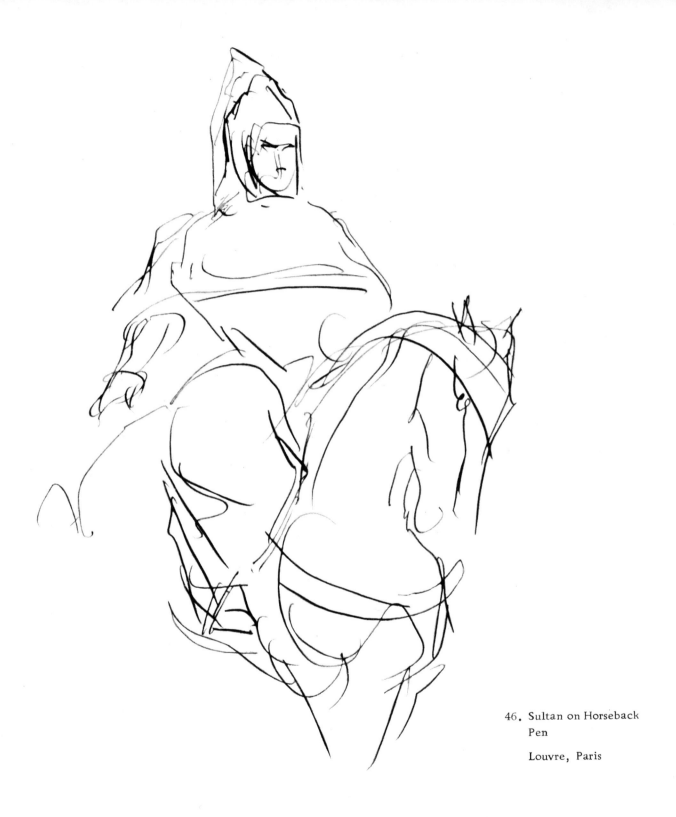

46. Sultan on Horseback
Pen

Louvre, Paris

III

Selections from the Writings

The texts are drawn from *Journal d'Eugène Delacroix* (ed. André Joubin, 3 vols., Paris, 1932 and 1950), *Correspondance générale d'Eugène Delacroix* (ed. André Joubin, 5 vols., Paris, 1935-1938); and *Œuvres Littéraires* (ed. Elie Faure, 2 vols., Paris, 1923). An English edition of selections from the roman exists : *The Journal of Eugène Delacroix* (trans. Walter Pach, New York, 1961).

⌒ Why not make a small collection of random thoughts which come to me from time to time, already molded and to which it would thus be difficult to attach others? Is it absolutely necessary that one produce a book, keeping within all the rules? Montaigne wrote *à bâtons rompus* (by fits and starts). These are the most interesting works.

If a man of talent would set down his thoughts on the arts, let him express them as they occur to him; let him not fear to contradict himself; there will be more fruit for his harvest amid the profusion of his ideas, even if contradictory, than in the skein of a work which has been combed, squeezed, and cut up, for the sake of concentrating on its form.

～ Painting.... that silent power which at first speaks only to the eyes and which then wins over and makes its own all the faculties of the soul.

Painting plagues and torments me in a thousand ways, indeed like the most demanding mistress.

～ What do you think has been the life of men who have raised themselves above the common herd? Constant strife.

The outcome of my days is always the same: an infinite desire for what one never obtains, an emptiness one cannot fill, an intense longing to produce in all ways, to battle as much as possible against time that inexorably sweeps us along.

On many occasions I have happily savored the feeling of liberty and self-possession which must be the only good toward which I aspire.

～ Glory is not an empty word for me.

Love of glory is a sublime instinct, given only to those worthy of achieving it.

All great men have had a premonition of their power and have taken in advance the place that posterity later accords them; how else can one explain this audacity in inventiveness.

Young artists, remember this well! Glory comes dearly. The fashion of the moment is all too tempting.

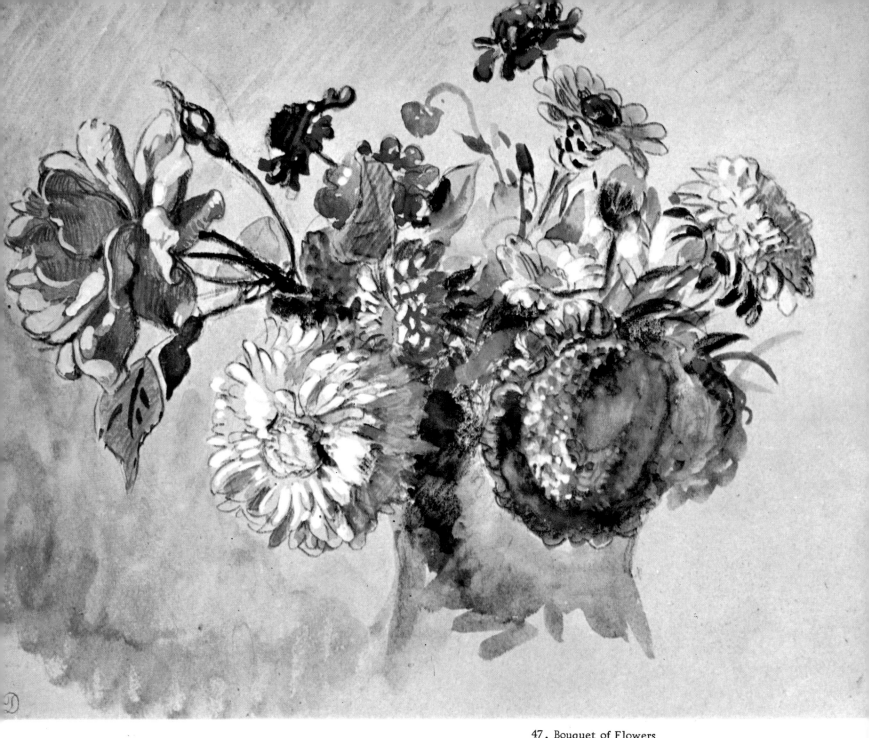

47. Bouquet of Flowers
Watercolor

Musée Fabre, Montpellier

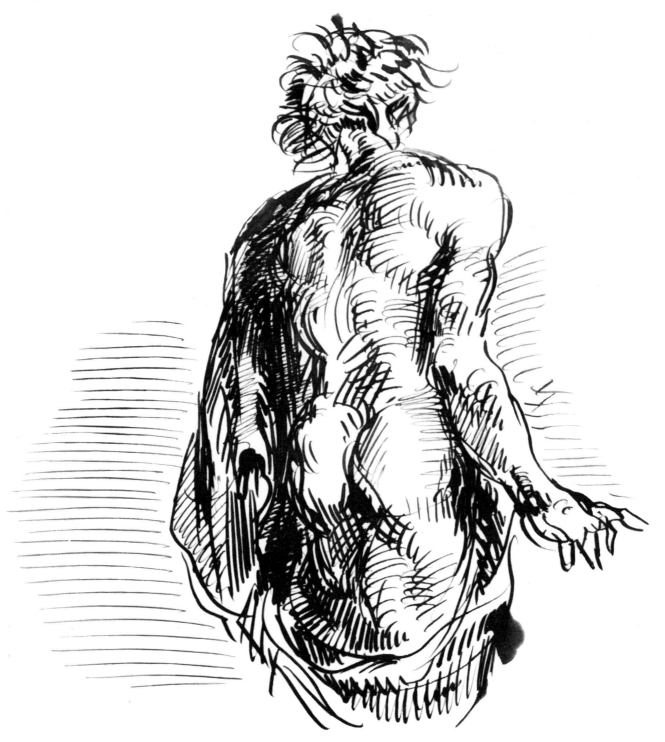

48. Study of a Nude
Pen

Louvre, Paris

～ Common men pass treasures by; they respond to the spectacle of nature as guests at a banquet who are neither hungry nor thirsty.

As soon as I find myself in the presence of the works of the princes of painting, I feel the need to be myself, to become original.

What makes men of genius or rather what they make, is not new ideas; it is the idea—which possesses them completely—that what has been said has still not been said enough.

The real primitives are the men of original talent.

～ Without boldness, and an extreme boldness, there are no beauties.
One must have great boldness to dare to be oneself.
One must be very bold. Thus one has to surpass oneself, in order to be everything that one can be.
I do not like reasonable painting at all.
There are no rules for great souls; rules are only for those who have merely a talent that can be acquired.
Reason must accompany all our flights of fancy.

～ There are black and yawning depths to be plumbed. If I am not writhing like a snake in the hands of a sorceress, I am cold.

Let those who work coldly keep still; do they know what it means to work under the spell of inspiration? What fear, what terror there is that you may awaken the sleeping lion whose roars shake your being to its very foundations.

~ All work in which imagination plays no part is impossible for me.

What are most real to me are the illusions I create with my painting. The rest is shifting sand.

It is in using the language of one's contemporaries that one must, as it were, teach them the things that this language does not express.

Before nature itself, it is our imagination which makes the picture; we see neither the blades of grass in a landscape, nor the blemishes of the skin in a pretty face.

The forms of a model, be they a tree or a man, are only a dictionary to which the artist goes in order to reinforce his fugitive impressions, or rather to find a sort of confirmation of them.

Novelty is in the mind that creates, not in the nature that is painted. ... You who know there is always something new, show it to them in that which they have failed to recognize. Make them believe that they have never heard of the nightingale or the vast ocean. ... Nature has put in safekeeping in the great imaginations to come more new things to say about her creation than she has created things.

~ One wants to enjoy everything and one doesn't know how to enjoy oneself. When you don't enjoy yourself, it is as if you are someone else. Most often, it is only in solitude that one can truly enjoy oneself, that is to say, be struck by the complete rapport that exists between exterior objects and our own nature.

Everything is a subject; the subject is yourself. It is within yourself that you must look and not around you. When you give yourself completely to your soul, it opens itself up fully and it is then that that capricious part of you offers the greatest happiness . . . to reveal it to others, to study oneself, to paint oneself continually in these works.

Why am I not a poet? But at least let me feel as much as possible in each of my paintings, what I wish to produce in the souls of others.

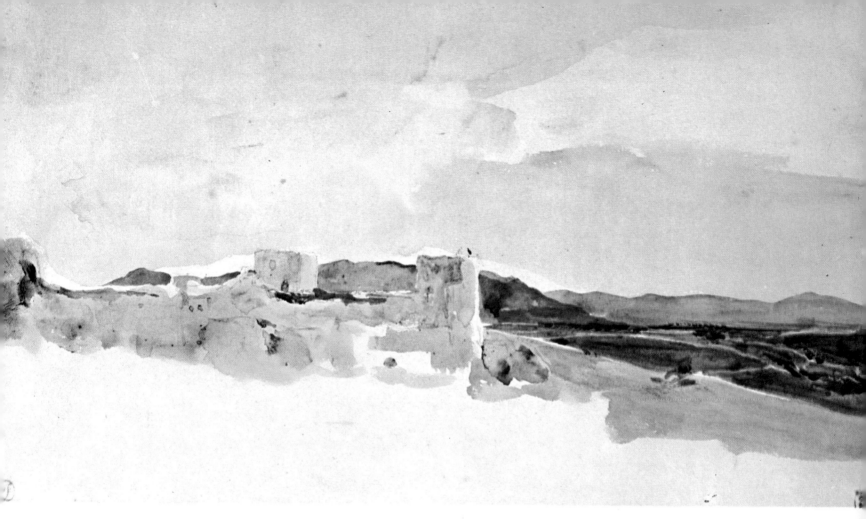

49. The Outskirts of Meknes
Watercolor

Musée des Beaux Arts, Poitiers

~ In order to have a renaissance of the arts, a renaissance of manners and morals would be necessary.

You live like wolves and your arts are doves.

One is only a master when one imparts to things the patience that is inherently theirs.

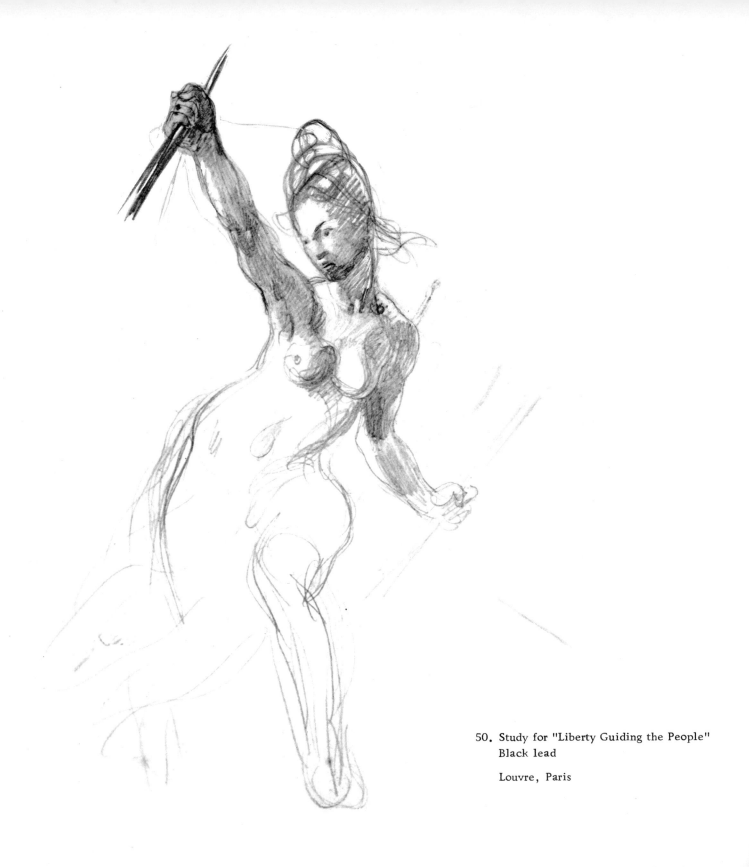

50. Study for "Liberty Guiding the People"
Black lead

Louvre, Paris

86

〜 I take all men for my friends.

I am only happy—completely happy—when I am with a friend.

When there is no longer affection for man, there is nothing left.

Happy or unhappy, I am almost always at one extreme or the other.

It is one of the great misfortunes of human existence that one can never be fully known and felt… and when I think about it, I realize that this is life's supreme affliction.

I must return to solitude.

The things that one experiences alone with oneself are very much stronger and purer.

What torments my soul is its loneliness. The more it expands with friends and the habits and pleasures of everyday life, the more it seems to escape me and retreat into its fortress.

〜 Realism should be defined as the antithesis of art.

The first of the arts—music—what does it imitate?

Cold exactitude is not art; ingenious artifice, when it *pleases* or *expresses*, is the whole of art. The so-called conscience of most painters is only bringing to perfection the art of the boring.

So, cursed realist, could you possibly produce the illusion that I am attending the spectacle you pretend to offer me? It is the cruel reality of objects that I flee when I take refuge in the sphere of artistic creation.

What is necessary is an apparent reality; it is literal realism that is stupid.

The daguerreotype: it is still only a reflection of reality, only a copy, false in a sense because of its very exactness.

It would be intriguing to write a treatise on all the falsities that constitute the true.

⌒ At this moment I am like a man who is dreaming and who sees things that he fears are going to escape him.

Imagine, my friend, what it is to see, lying in the sun, strolling in the streets, or repairing shoes, men who are like consuls, each one a Cato and a Brutus, ... These people own only the blankets they walk about in, sleep in, and are buried in and yet they seem to be as satisfied as Cicero must have been with his magistrate's chair. ... Antiquity has nothing more beautiful.

The heroes of David and company cut a sad figure with their rose-colored limbs next to these children of the sun.

...the living and vibrant sublimity that walks the streets here and whose reality completely overwhelms you.

Beauty walks the streets. ... The Romans and the Greeks are right outside my door. I've laughed heartily over David's Greeks, though not of course at his sublime brush. I know them now; the marbles are truth itself but you have to know how to read them and we poor moderns have seen only hieroglyphics. ... Rome is no longer in Rome.

⌒ "Man is born free." Never has a weightier piece of foolishness been uttered, no matter how great the philosopher who said it.

1848. This liberty won at the cost of battles is not really liberty at all.

The muses are, no matter what they say, friends of peace; it is the stimulation of the mind that makes the brush move every which way.

How old we are and how old it all makes us! I have seen enthusiasts and they were young. Nothing reveals better than revolutions the absolute necessity that the old surrender their place to young blood. As for myself, I am as cold as marble and perhaps I will finish by being as insensitive.

When they've got travelers comfortably installed in a cannon, civilization will doubtless have taken a giant step; we are marching toward that happy time which will eliminate space but which will not have eliminated boredom.

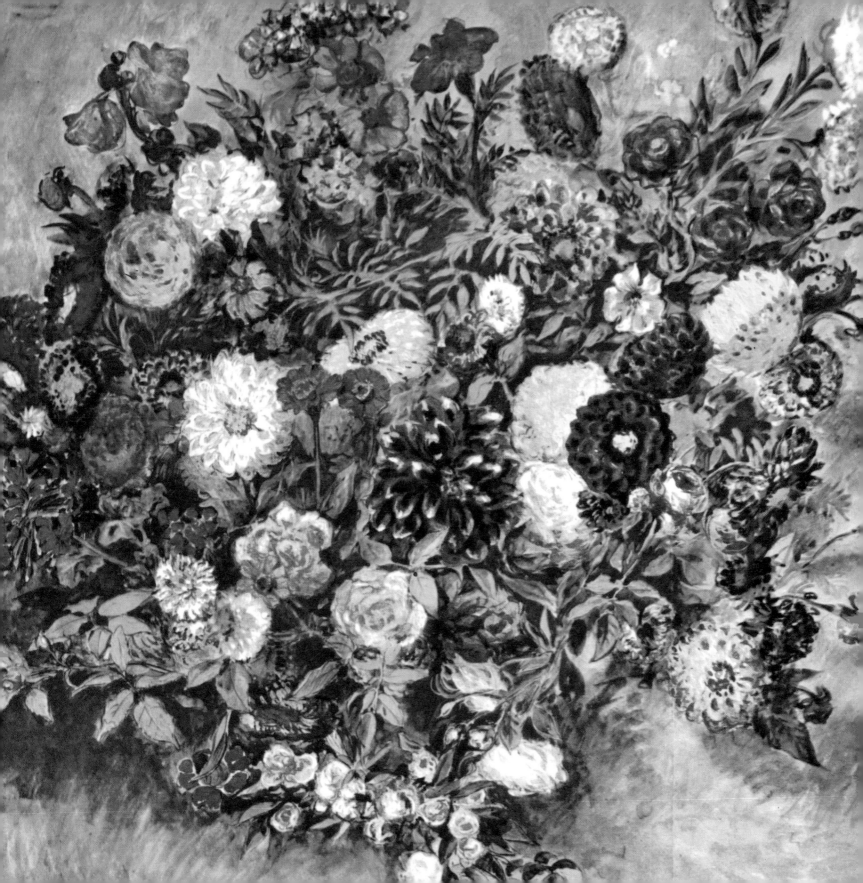

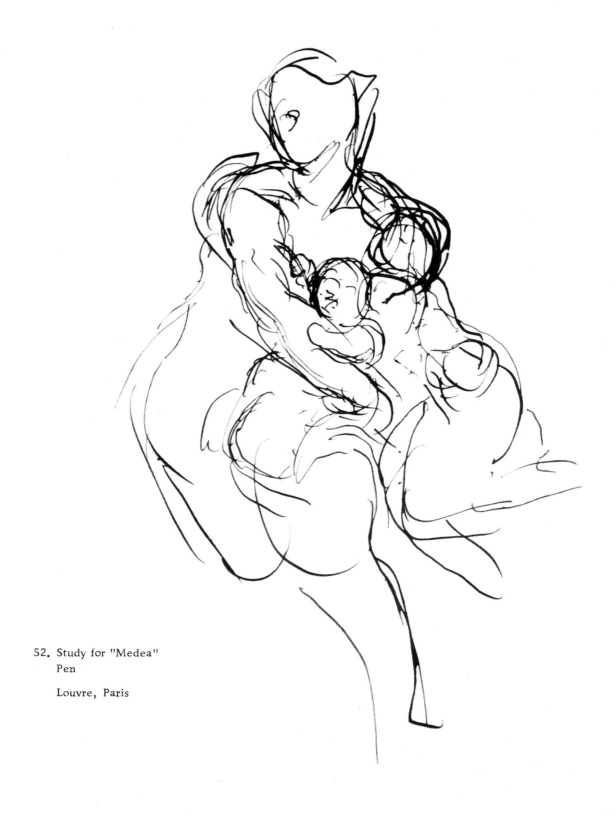

52. Study for "Medea"
 Pen

 Louvre, Paris

90

⌇ The enemy of all painting is gray.

Radically speaking, there are neither lights nor shades. There is a color mass for each object, reflected differently on all sides.

I discovered one day that linen has green reflections and violet shadows. I notice that it is the same with the sea... it is probable that I will find that this law applies to everything.

The shadow of these figures is so violet that the terrain becomes yellow.
There are never parallels in nature, be they straight or curved.
When the tones are right it is as if the lines draw themselves.

Here are documents of which a scholar would perhaps be proud; I am even more so, for having made well-colored paintings before learning of these laws.

The special charm of watercolor, beside which any painting in oil always appears rusty and yellowed, is due to the inherent transparency of the paper.

Sonority is to be blamed when it is substituted for the idea, and yet one must admit that in certain sonorities, independently of profound expression, there is a pleasure for the senses. It is the same thing with painting.

⌇ Champrosay: I always love this countryside; I become easily attached to the places I live in: my mind and my heart bring them to life.

Champrosay: The feeling of calm and freedom that I enjoy here is inexpressibly sweet. Then, too, I let my beard grow and I practically wear wooden shoes.

Dieppe: Outside of Paris, I feel more like a man; in Paris I am only a *Monsieur*. There one finds only ladies and gentlemen, that is to say, dolls; here I see sailors, farmers, soldiers, fishmongers.

Besides, I like moderate circumstances. I have a horror of luxury and display; I like old houses, antique furniture; things that are brand new don't appeal to me at all.

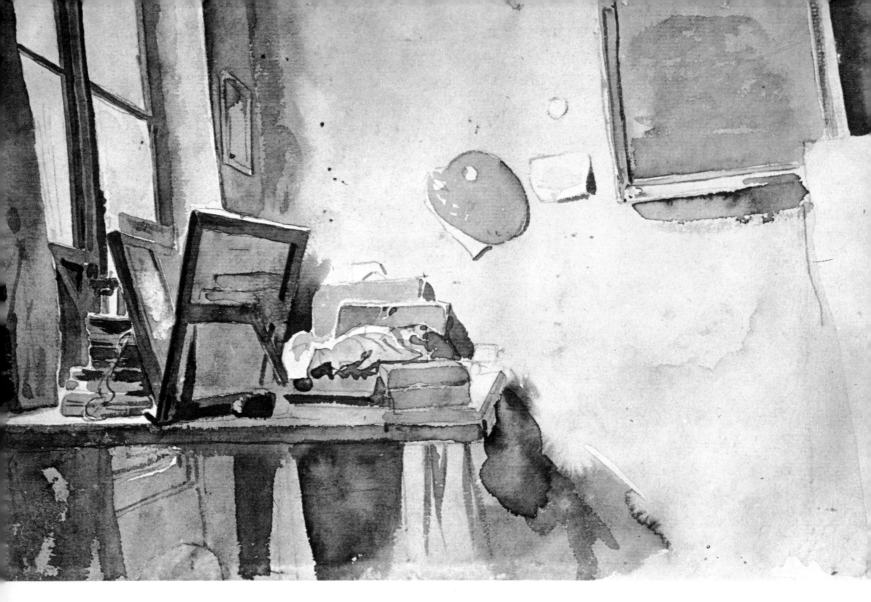

53. Delacroix's Studio
Wash
Louvre, Paris

54. Horses
Pen, page of studies

Louvre, Paris

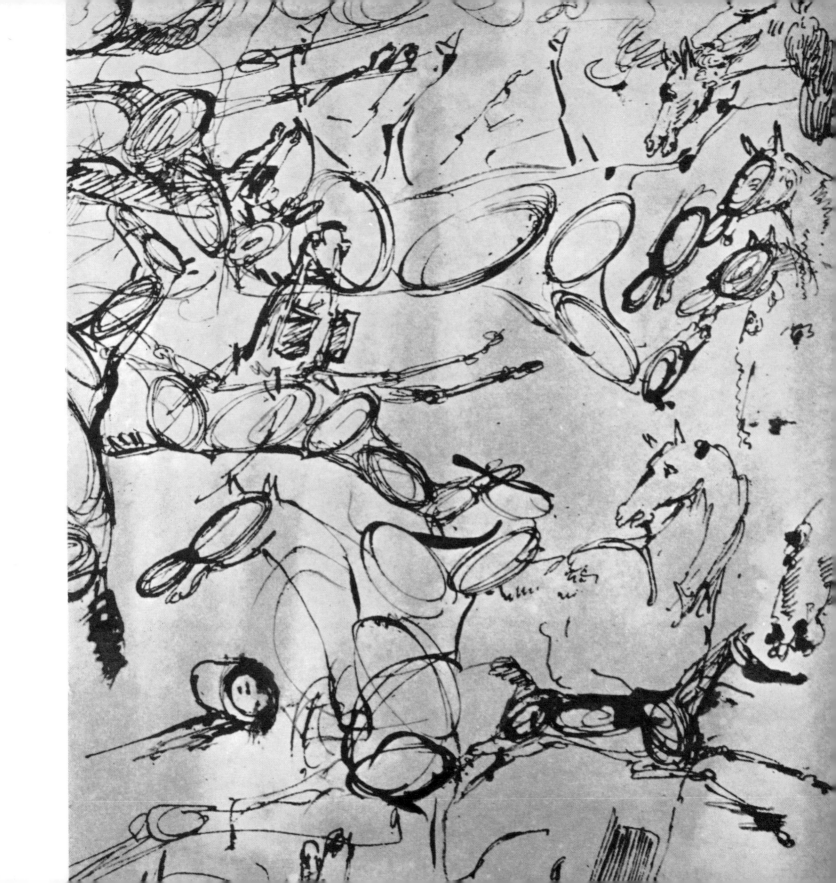

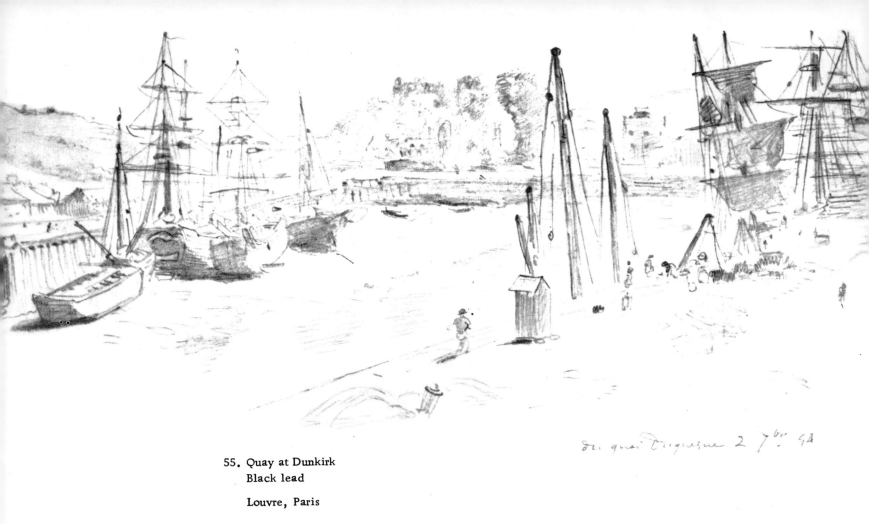

55. Quay at Dunkirk
 Black lead

 Louvre, Paris

～ You will please with a pure and absolute pleasure.

 They say that work is intoxication; it is a drunkenness, as I know so well.

～ This admirable poem, this human body, which I am learning to read.

 Music is the voluptuousness of the imagination.

 The most beautiful pictures I have seen are certain Persian carpets.

〜 What awkwardness and magnificence in Titian! What admirably rhythmic movement in Raphael's lines!

Dürer, Holbein, the German masters in general, Lucas van Leyden, Memling, among the Flemish primitives, with their figures that are often pitiful, thin, contorted, yet teeming with beauties.

Rubens: Glory to that Homer of painting, to that father of warmth and enthusiasm. ...

I am looking at Rubens' *Hunts*. ... I love his grandiloquence, I love his freely conceived and exaggerated forms. I adore them with all the contempt that I feel for the syrupy dolls who swoon at fashionable paintings.

I have made some sketches after Rubens' *Hunts*; there is as much to learn from his exaggerations and over-blown forms as from exact imitations.

The unfinished appearance of Rembrandt's works, the exaggerations of Rubens'. Mediocre men cannot have such daring; they never get outside themselves.

Perhaps it will be discovered that Rembrandt is a far greater painter than Raphael. In writing this blasphemy I know I will make every academic's hair stand on end.

〜 These men so violently in love with style, who prefer to be stupid rather than to lack an *air of gravity*. Apply this to Ingres and his school.

Ingres has nothing Homeric about him but his pretension. He traces the exterior of things.

I saw Ingres' exhibition. The sense of the ridiculous dominates it to a great degree; it is the complete expression of an incomplete intelligence; effort and pretension are everywhere.

I went to see the Courbet exhibition. ... I discovered a masterpiece [*The Painter's Studio*]. ... They have refused one of the most singular works of our time, but a sturdy fellow like that will not be discouraged so easily.

Those who would be tempted today to condemn Beethoven or Michelangelo in the name of regularity and purity, would have absolved them and praised them to the skies in a time when other principles triumphed.

The examples of the masters; they are no less dangerous than they are useful; they mislead or intimidate artists; they arm the critics with terrible arguments against any originality.

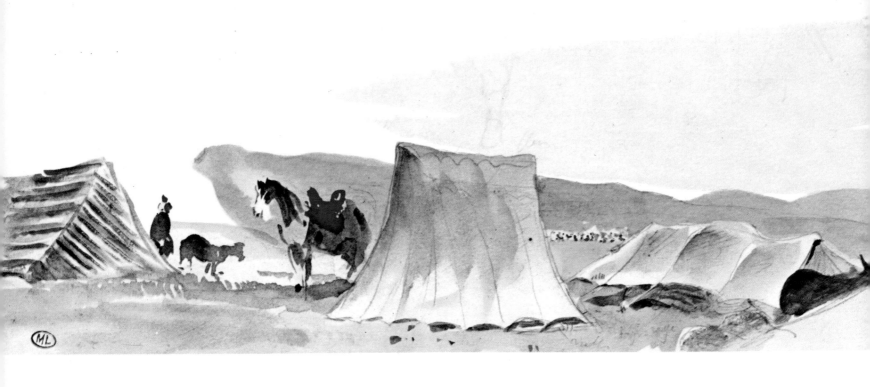

— The original idea, the sketch, which is, so to speak, the egg or embryo of the idea, is usually far from complete; it contains everything, if you will, but it is necessary to free this everything.

In painting, a few beautiful lines, a sketch with great feeling, can equal, in terms of expression, the most finished productions.

This is the way one ought to do sketch-pictures, which would have the freedom and freshness of rough drawings.

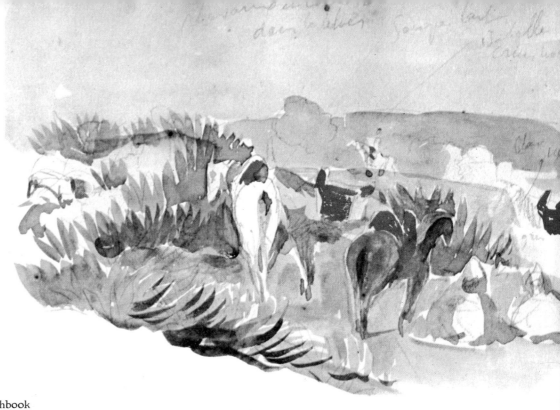

56-57. Encampments

Watercolors, pages from a sketchbook

Louvre, Paris

⌒ Study without respite first; once you begin, make mistakes if necessary, but execute freely.

There are two things that experience must teach us: the first is that one must correct a great deal; the second is that one must not correct too much.

Execution in painting must always have its source in improvisation. The painter's execution will only be beautiful on the condition that he allows himself a small measure of abandon and discovers in the process of doing.

97

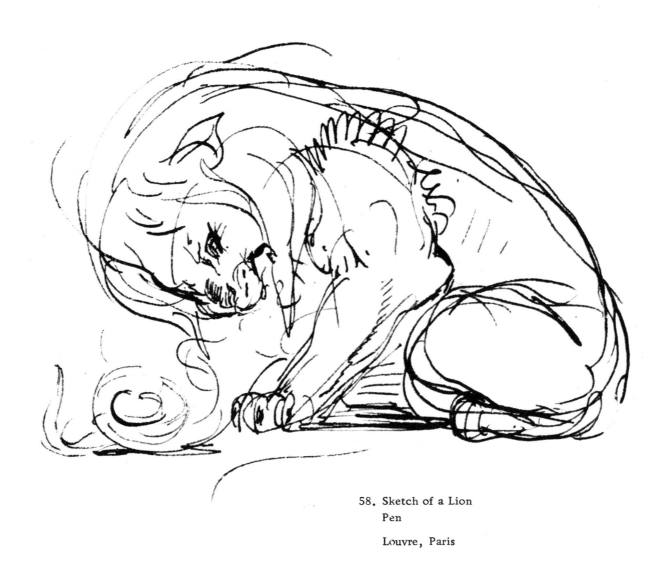

58. Sketch of a Lion
Pen

Louvre, Paris

⏤ Success in the arts is not a matter of abridging, but of amplifying, and, if possible, of prolonging the sensation by all available means.

~ I prefer to converse with things rather than with men. ... The work is worth more than the man. It may perhaps be that Corneille was insufferable.

Regret for the passage of time, the charm of youth, the freshness of first impressions has a greater effect on me than the spectacle itself. The smell of the sea, above all at low tide when its charm is perhaps the most penetrating, brings me back again with an incredible power, among those dear objects and dear moments that are no more.

To feel oneself surrounded by papers that speak, I mean drawings, sketches, souvenirs; to read two acts of *Britannicus*, being more astonished each time at that pinnacle of perfection. ... therein lies a happiness which at many moments seems superior to all others.

~ Great interruption in these poor everyday notes: I am very saddened by it; it seems that these trifles, written in passing, are all that remains to me of my life, as it runs out.

There is something within me, what then is it.... And men often find themselves utterly unable to do anything, prisoners of some horrible, horrible cage.... One cannot always name what it is that encloses them, walls them in, seems to bury them, but one feels everywhere these indefinable bars, these grills, these walls.... And then one asks oneself: my God, is it for long, is it for always, is it for eternity?

What a pity that experience comes just at the age when one's powers begin to disappear.

Death: What will we find beyond? Night, hideous night.